HAWAII

HAWAII

David Muench

SKYLINE
PRESS

Produced by
Roger Boulton Publishing Services, Toronto
Designed by Fortunato Aglialoro

© 1984 Oxford University Press (Canadian Branch)
SKYLINE PRESS is a registered imprint of
Oxford University Press

ISBN 0-19-540-618-4
1 2 3 4 – 7 6 5 4
Printed in Hong Kong by
Scanner Art Services, Inc., Toronto

Introduction

The Hawaiian islands were born from the Pacific depths some 40 million years ago, spectacular landforms created in one tiny spot in that vast expanse of ocean by layer upon layer of lava building up from vents in the earth's thin crust to form an extensive chain of undersea mountains. The islands that we know are but the tips of this range. Rising almost 30,000 feet from the ocean floor, Mauna Kea and Mauna Loa are the highest mountains on the planet Earth, and Mauna Loa is building its shell-like dome ever higher, with fiery eruptions and overflowing rivers of lava. Pele, the goddess of volcanoes, is active still, as evidenced by the recent accretions of lava to the growing massif on the Big Island.

Mark Twain once called them 'the loveliest fleet of islands anchored in any sea.' An overview of this mid-Pacific volcanic chain would show almost 130 points of land above sea-level, stretching 1,500 miles across the ocean. The Northwestern, or Leeward Hawaiian Islands, 1,200 miles of the chain, are made up of tiny, windswept, bare reefs, islets and ocean-pounded shores. The Windward or Southeastern Hawaiian Islands, spanning some 300 miles, are Hawaii, Maui, Molokai, Kahoolawe, Lanai, Oahu, Kauai, and Niihau.

The Big Island of Hawaii is lofty and spacious, with varied landscapes around the main volcanoes of Mauna Loa, Mauna Kea, Haulalai, and famous Kilauea in Hawaii Volcanoes National Park.

Maui's two mountains, Haleakala and Puu Kukui (the West Maui Mountains), are joined by a broad plain. Deep gorges such as Iao Valley cut into the West Maui Mountains with razor-edged ridges and pinnacles. Steep-walled valleys with heads like amphitheaters expand to form serrated ridges and sharp peaks. The summit area of Haleakala contains Hawaii's other National Park and the Hana coastline lies below to the east.

Molokai has a northeast face of rugged, impenetrable mountains and seacliffs, gathering the tradewinds from two or three thousand feet above the

ocean, in contrast to the dry, flat, western region of Mauna Loa. The island enjoys a quiet, traditional style of living. Lanai is a lower and miniature blend of the elements that go to make up the other islands.

About eighty per cent of the entire Hawaiian population lives on Oahu, a large part of the island being comprised of Honolulu. Massive buildings, commercial and military establishments, Pearl Harbor, and Waikiki Beach, bring a constant flow of people all year round. The Leeward Waianae Range and the Windward Koolau Range are the major landforms.

Kauai, being older than the other islands, is the most eroded. Mt Waialeale on Kauai, with 486 inches of rainfall a year, is reputed to be the wettest spot in the world. Its ridge holds a primeval garden and bog known as Alakai Swamp, and the mountain crowns a lush, green, jumbled scenery, that includes landforms displaying such powerful stream-erosion and rain-battered seacliffs as Waimea Canyon and Na Pali coast, where water leaps more than 500 feet in the air.

Hawaii Nei has been shaped by the capricious forces of fire, magma, rains, and winds, and now, most recently, by man.

The Hawaiian Islands have been isolated by space and, until recently, in time. Geologically they are young, one of the newest parts of the earth, and geographically they are remote, lying some 2,000 miles away from the nearest continent. Their pristine isolation has nurtured a remarkable variety of endemic plants that run a riot of color, shape and fragrance. The saturated hues of orchids and hibiscus, ginger and plumeria, and the larger pandanus, tree ferns, banyans and poinciana, all vie for our attention. Ohia, koa, kakui and coco palm only begin to hint at the magnificent flora of the islands.

The extremes of Hawaiian topography and the richness of Hawaiian flora are framed in a spectacular diversity of weather, landscape and light. Desert and lavabed, snowfield and tropical rainforest, grassland, blacksand beach and coral reef, rainbow and mist, all these blend into a tapestry of things Hawaiian. The landscape realist who comes in touch with such a concentration of natural wonders is overwhelmed. The interaction of land and sea, the blend of opposites, sets up a resonance, offers a harmony, unveils a mystery. Small shells washing up on a Niihau beach share the same splendor as the massive

mountain bulk of Mauna Loa. They form a synthesis, subtle and unforgettable as Hawaiian legends.

First impressions from my earliest visits to the Islands were fleeting and ephemeral; days full of tropical clouds, surging waves, changing landscapes, blowing winds in the palms, coral beaches, sunshine. Everything seemed to be in restless, stacatto movement, a sensory kaleidoscope. Reason enough to return. . . .

Later journeys brought harmony, land and sea merging into oneness, a tuning-in to the timeless, natural flow. The tradewinds became a constant, with their daily, windward showers, and the windward whitecapped sea in motion, or an early morning leeward calm. The clouds followed the sun over Haleakala Crater. All these things had their constant pattern of light and timing, a meaning and a unity. I tried in the intervals to set down the pattern, to trace the flow of this unique reality, to picture it in the camera's moment. The photographs became an intensely personal gathering of these phases of island time.

I have always been fascinated by petroglyphs, symbols and images from past cultures that were interwoven with nature. Their meanings and motives are wrapped in mystery, but they became symbolic for me, as they were for the ancients who made them, symbolic of a linkage and a survival in this awesome, benign environment. Perhaps the separation of time is only illusory and the reality is in this mystery, the sense of being at one with the place.

I hope that this gallery of images taken with love will help to heighten our caring awareness of the power and beauty that is natural Hawaii. . . .with Aloha.

DAVID MUENCH, May 1984
Santa Barbara, California

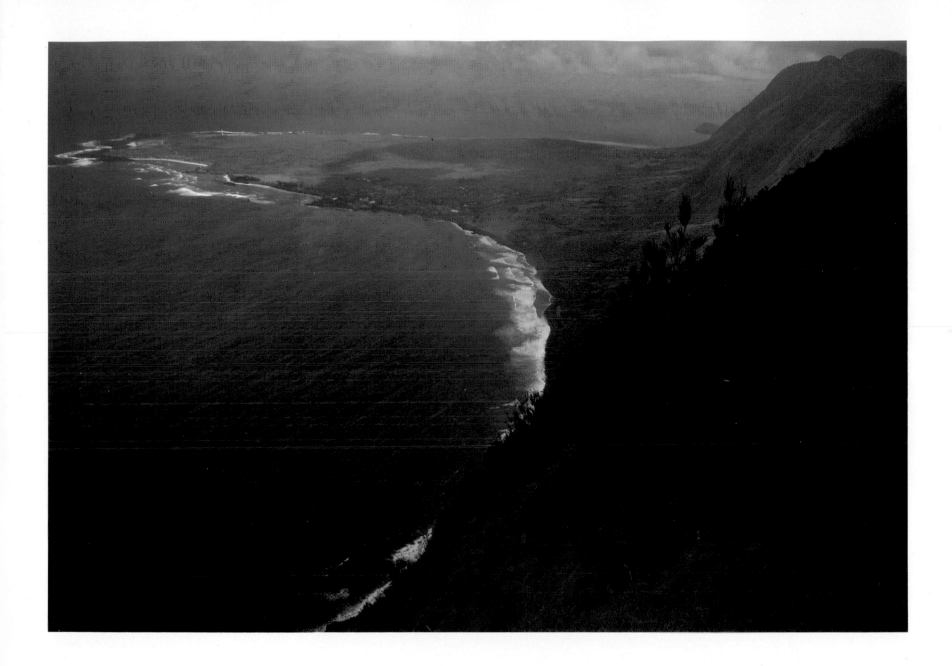

1 Kalaupapa National Historical Park, Molokai

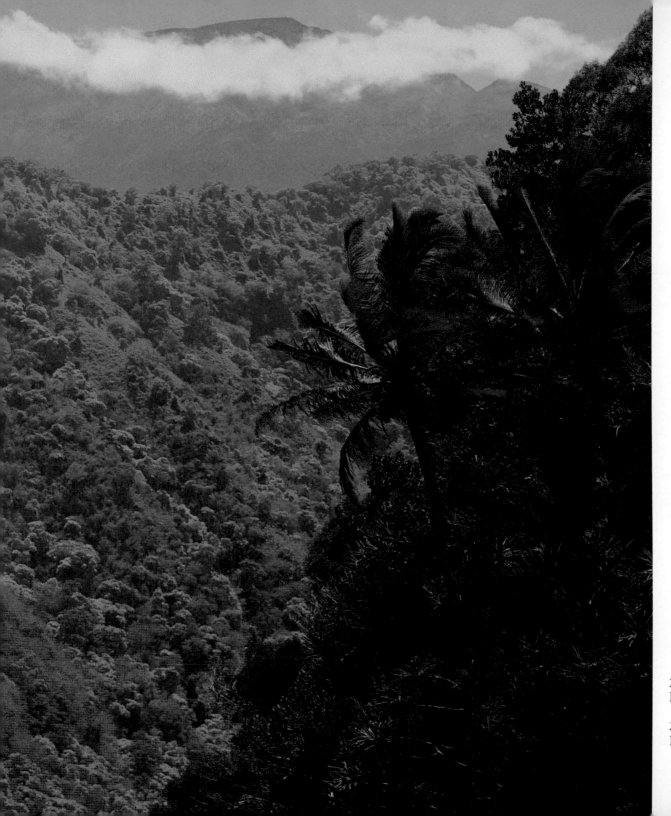

2 Up Keanae Valley to Haleakala Crater Rim, East Maui

3 *(right)* Tree Heliotrope on Koki Beach Park, Hana Coast, Maui

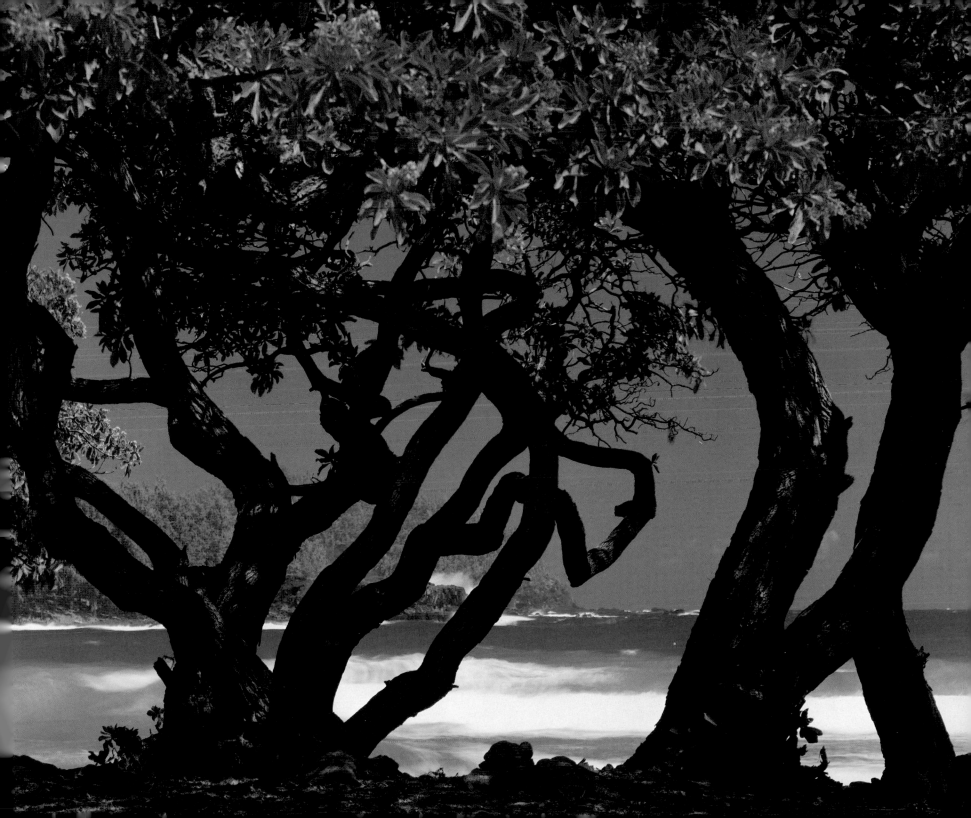

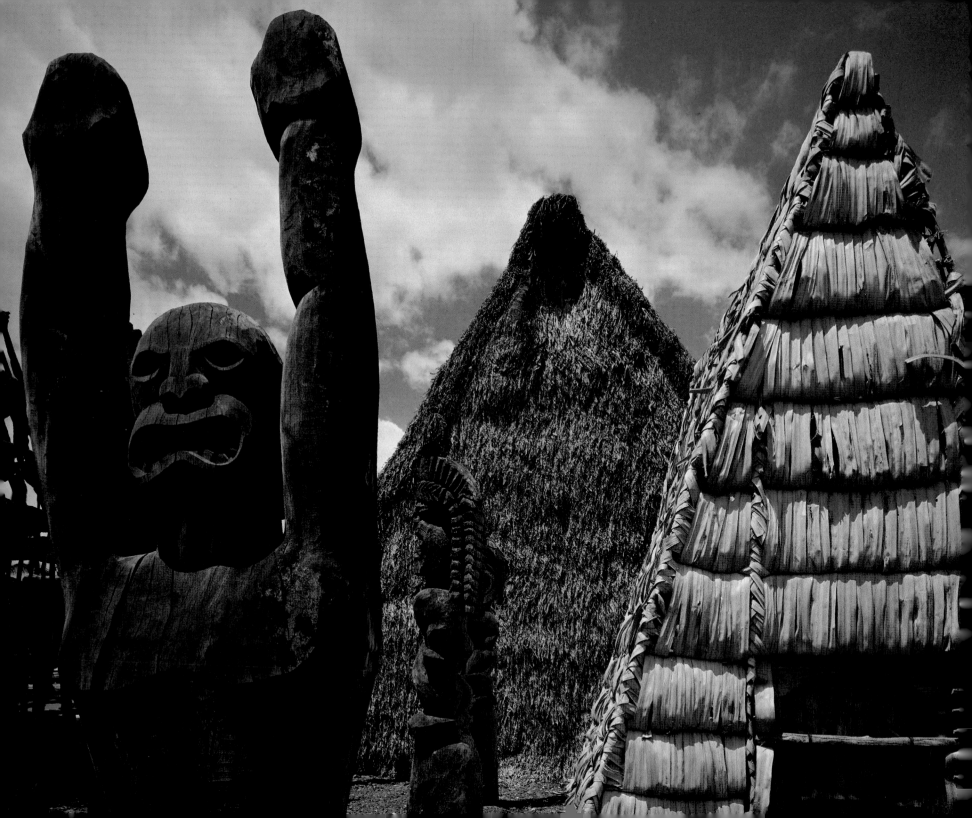

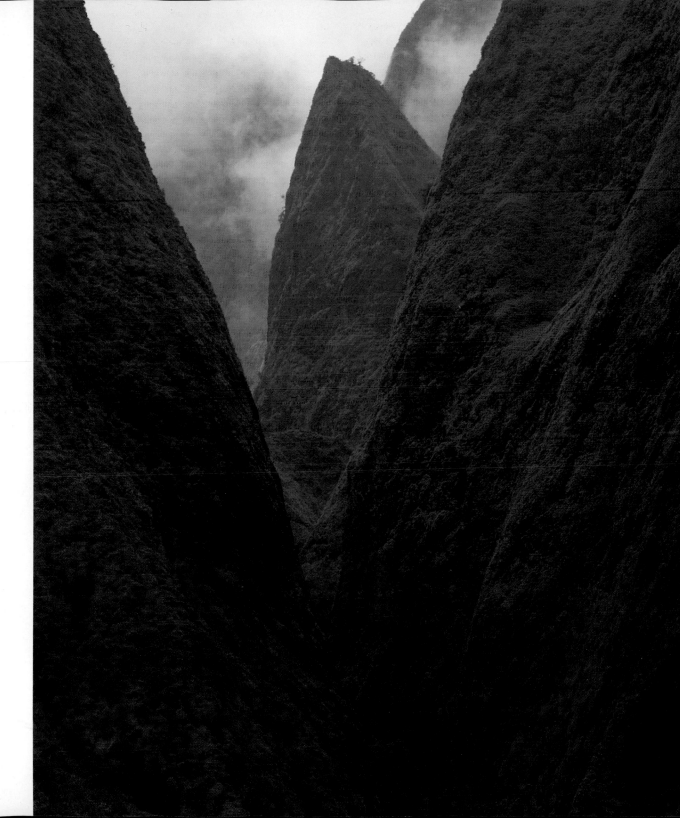

4 *(left)* Hulihee Palace, Kailua Bay, Kona Coast, Hawaii

5 Below Puu Kukui, Iao Valley, Maui

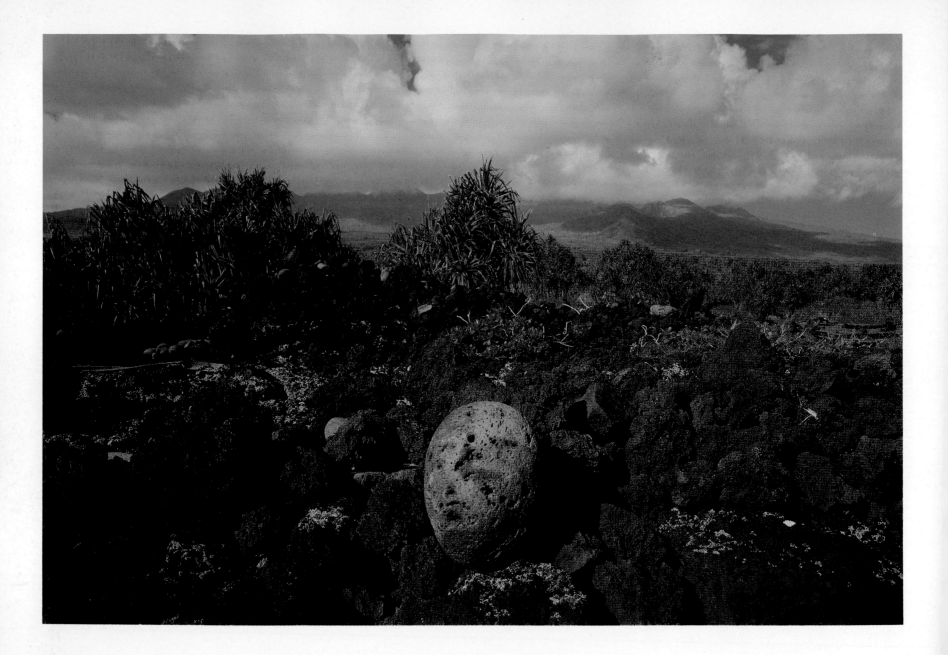

6 Walls of ancient *heiau* (temple), Waianapanapa, Hana Coast, Maui

7 *(right)* Amau fern above Kalalau Valley, Kauai

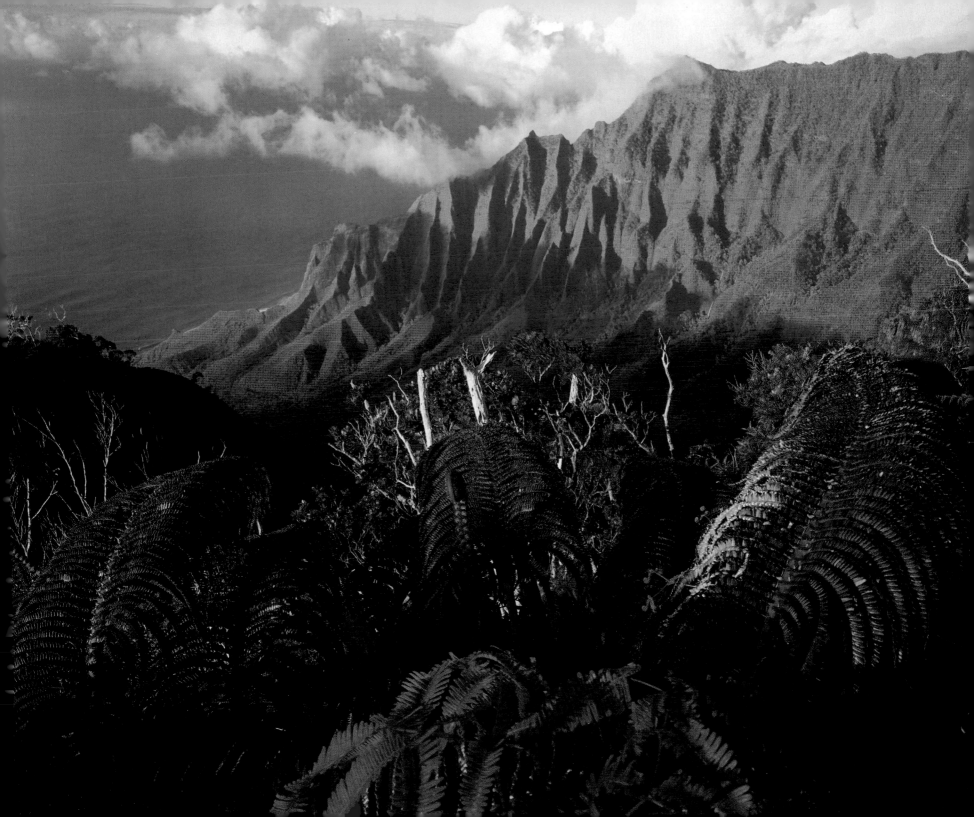

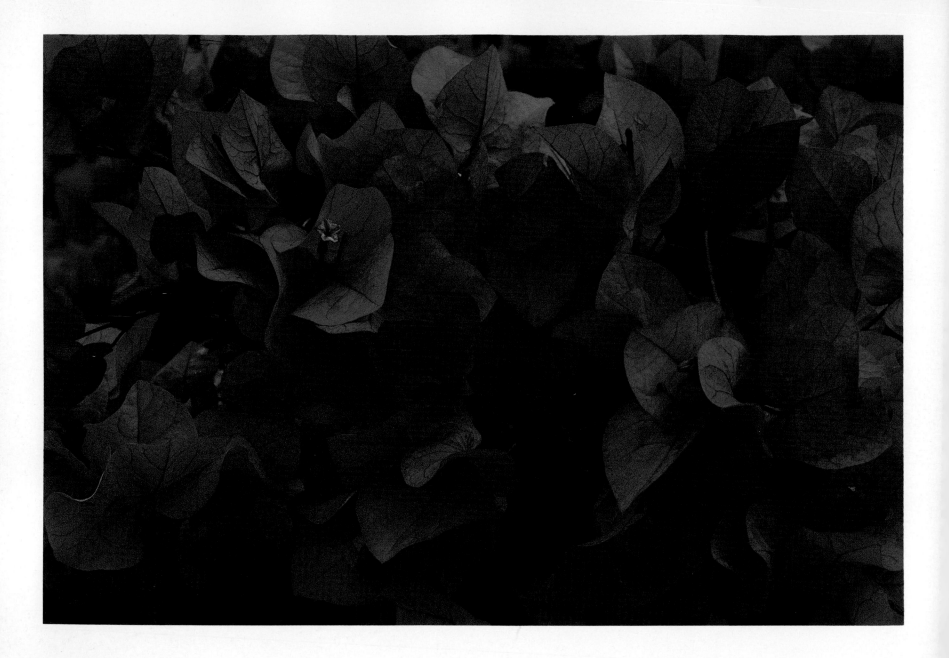

8 Bougainvillea in Olu Pua Botanical Gardens, Kauai

9 *(right)* Rare clearing of Waialeale top (Earth's wettest area)

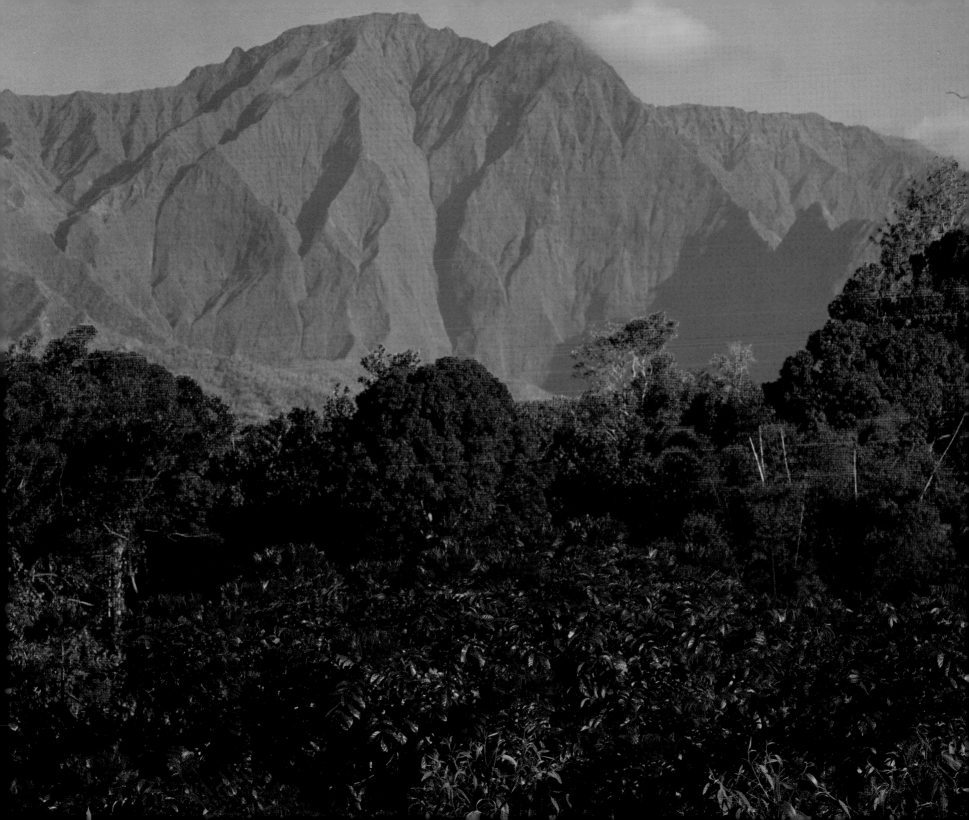

10 Pali Kalahaku rim and Kupaoa plant, Haleakala National Park, Maui

11 *(right)* Coco palms and lanai, Lahaina, West Maui

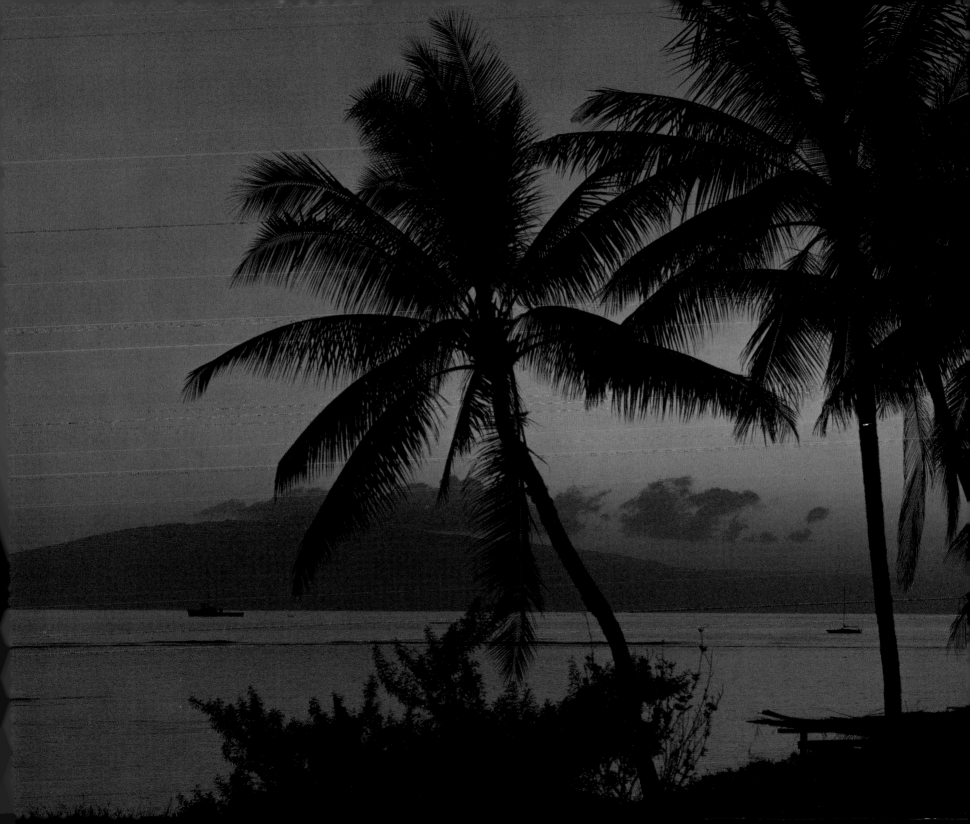

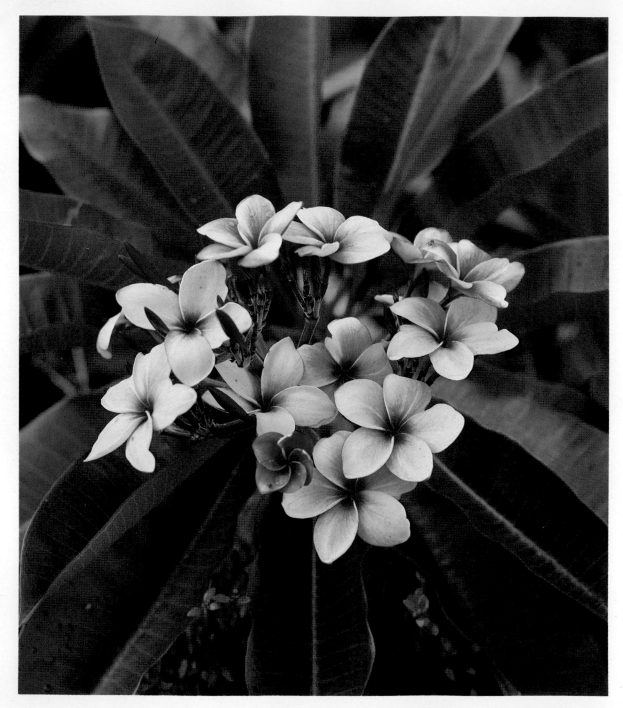

12 Crown of plumeria, Kalapana Coast, Hawaii

13 *(right)* Cascade amid tropical jungle of trees, eucalyptus in fields above, Hamakua Coast, Hawaii

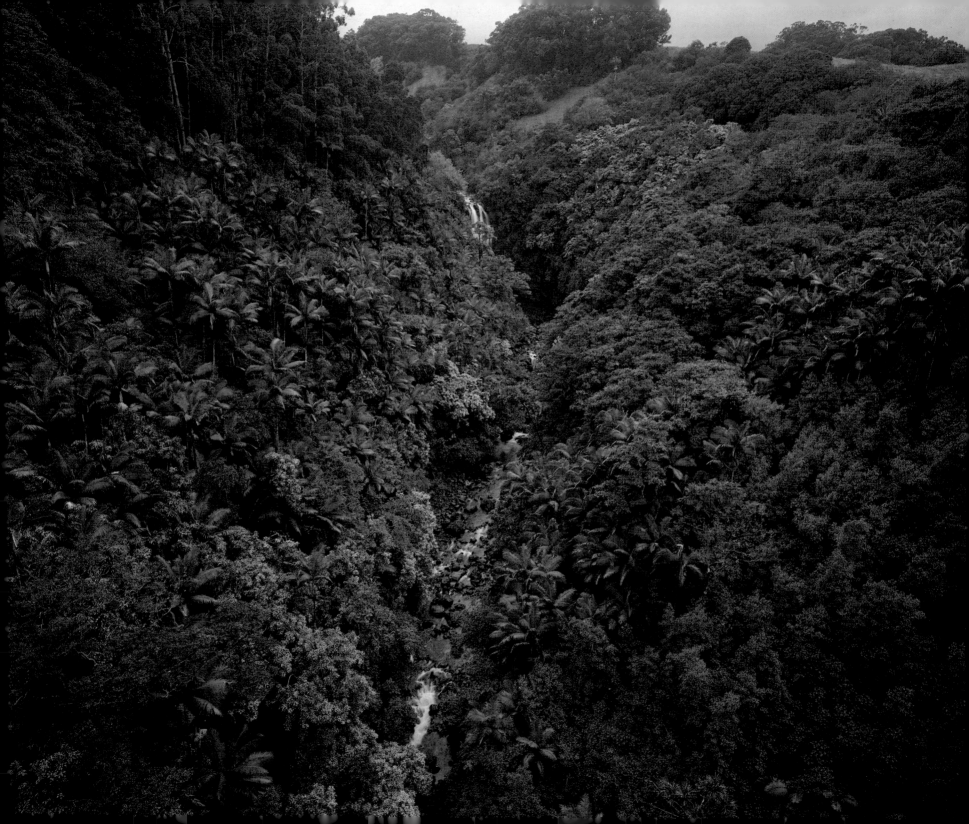

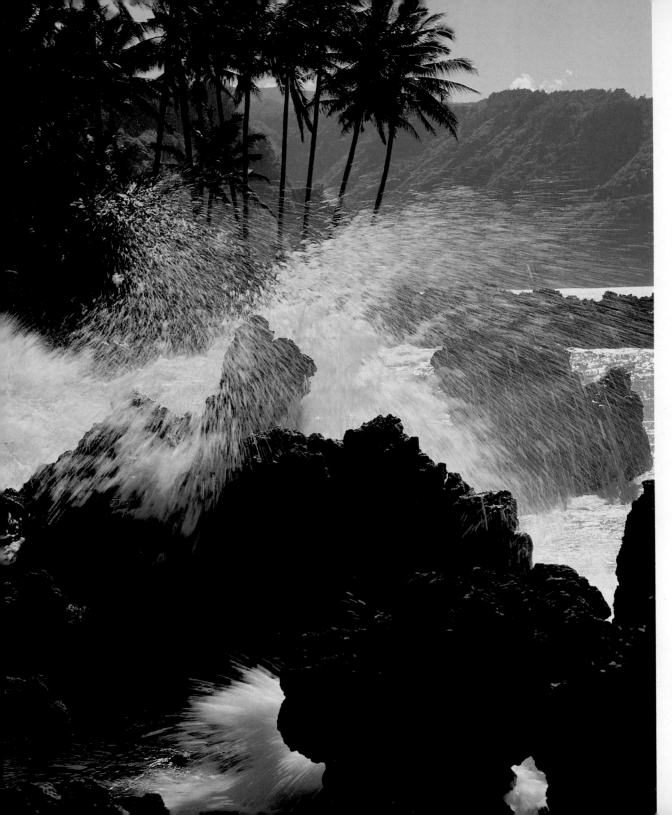

14 Wave splash in volcanics on Keanae
Peninsula, Hana Coast, East Maui

15 *(right)* Beach naupaka on jumbled
volcanics, Keanaa, Keanae Peninsula, Maui

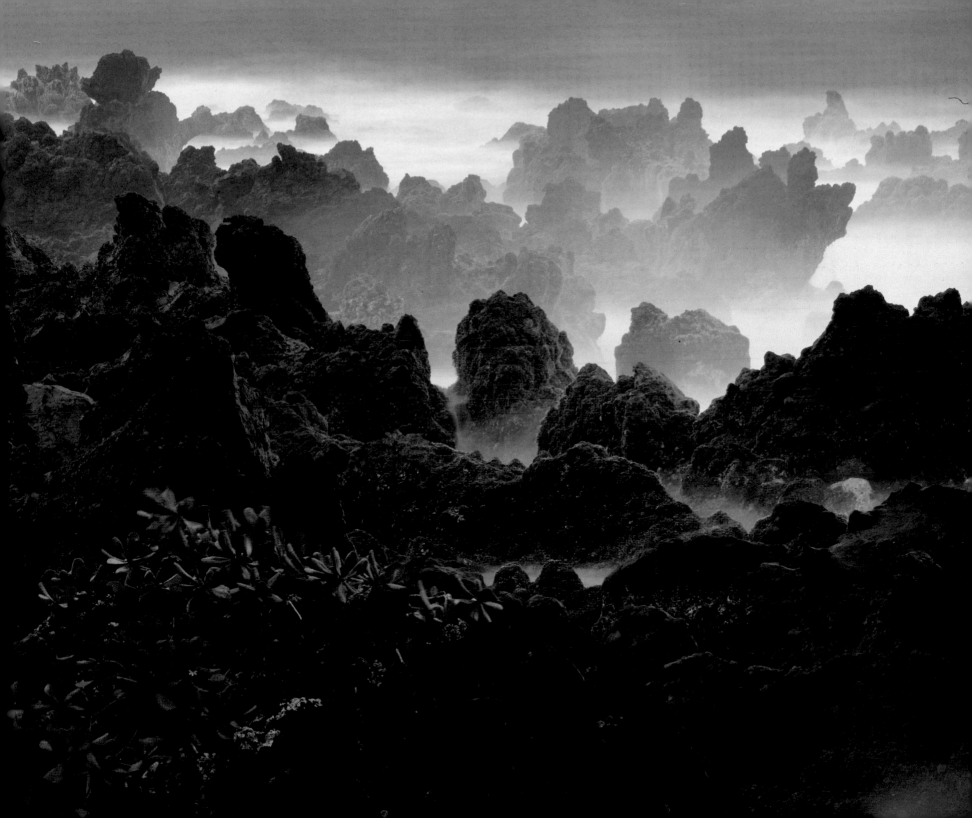

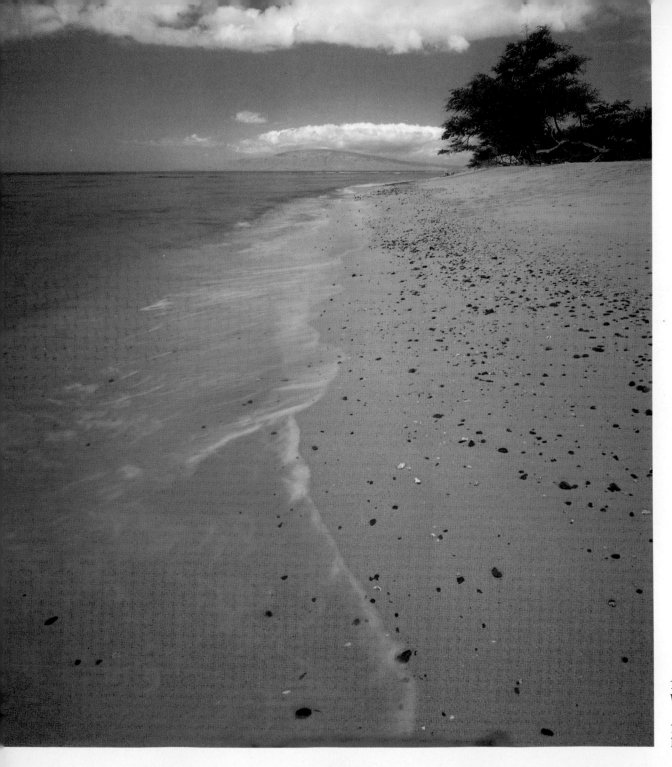

16 Ukumehame Beach and kiawe tree, West Maui

17 *(right)* Beach naupaka at Barking Sands Beach, Na Pali Coast, Kauai

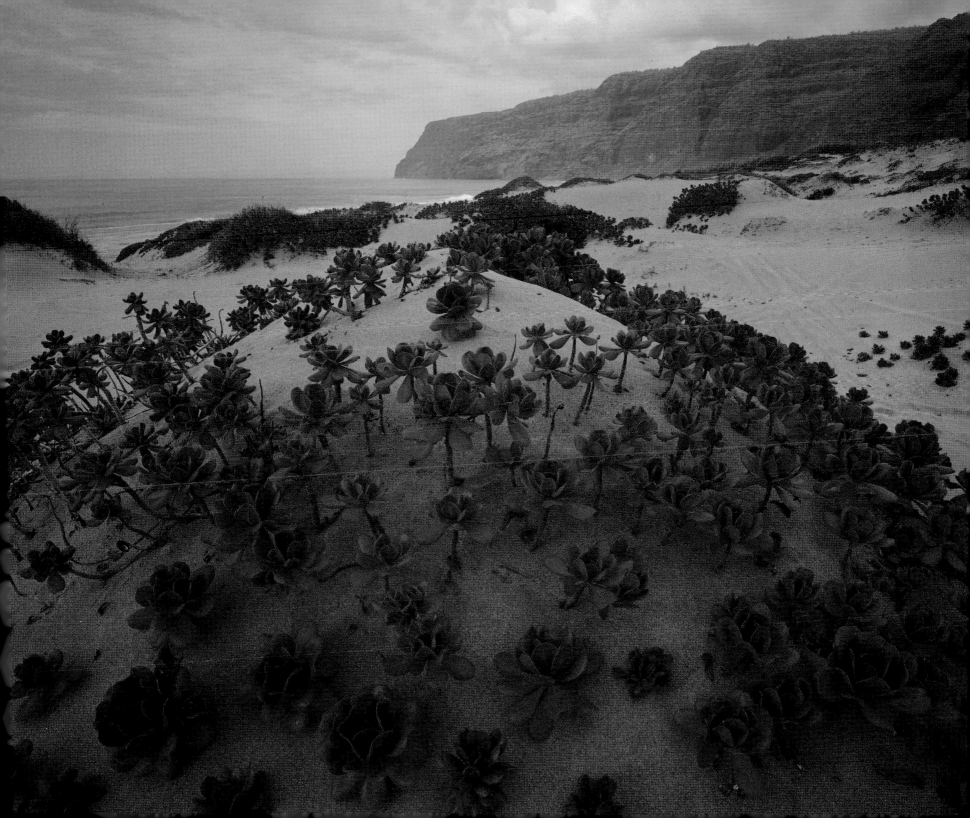

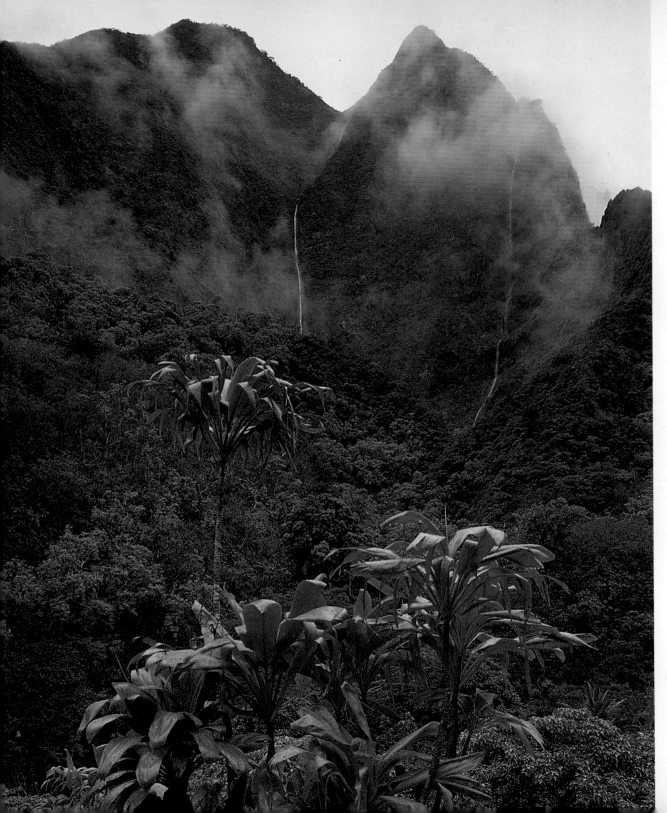

18 Rain-soaked Kapilau Ridge and ti plants, Iao Valley, West Maui Mountains

19 *(right)* Mauna Loa from Mauna Kea, Hawaii

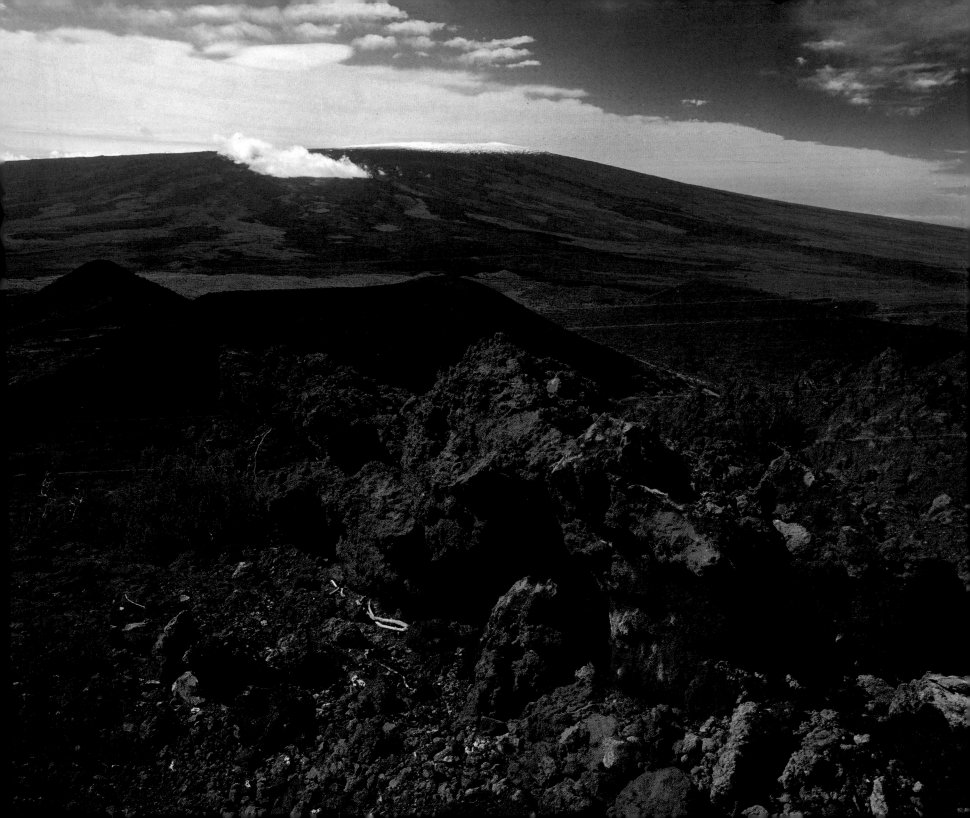

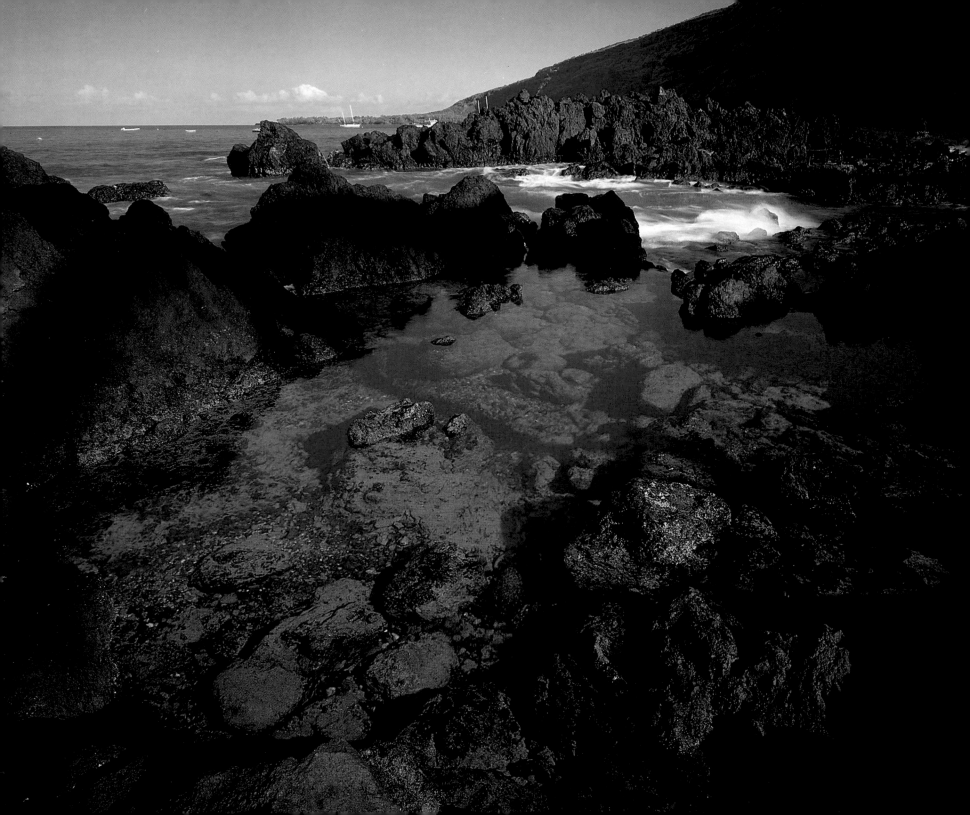

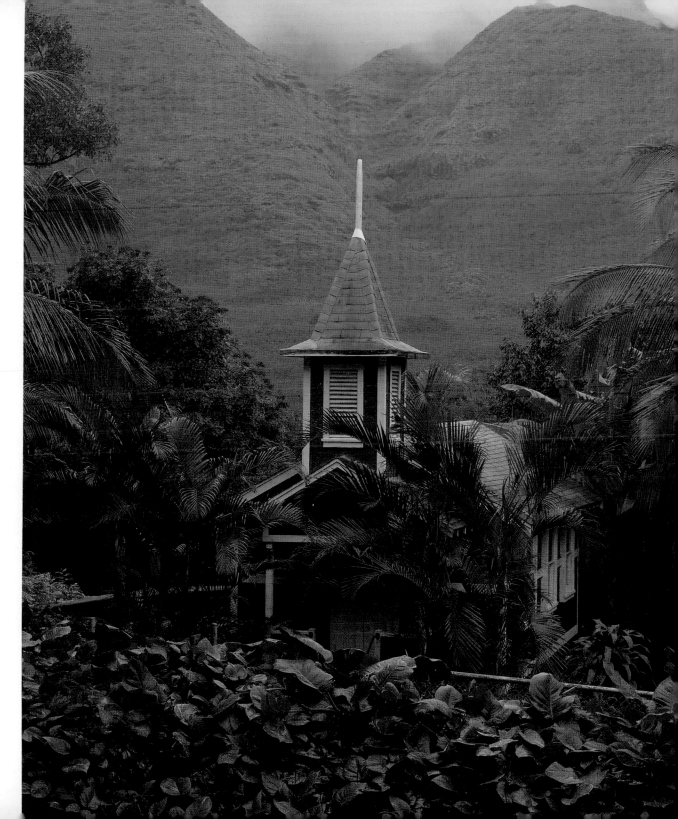

20 *(left)* Tidal pools in Captain Cook Inlet, Kona Coast, Hawaii

21 Congregational Church, Halawa Valley, Molokai

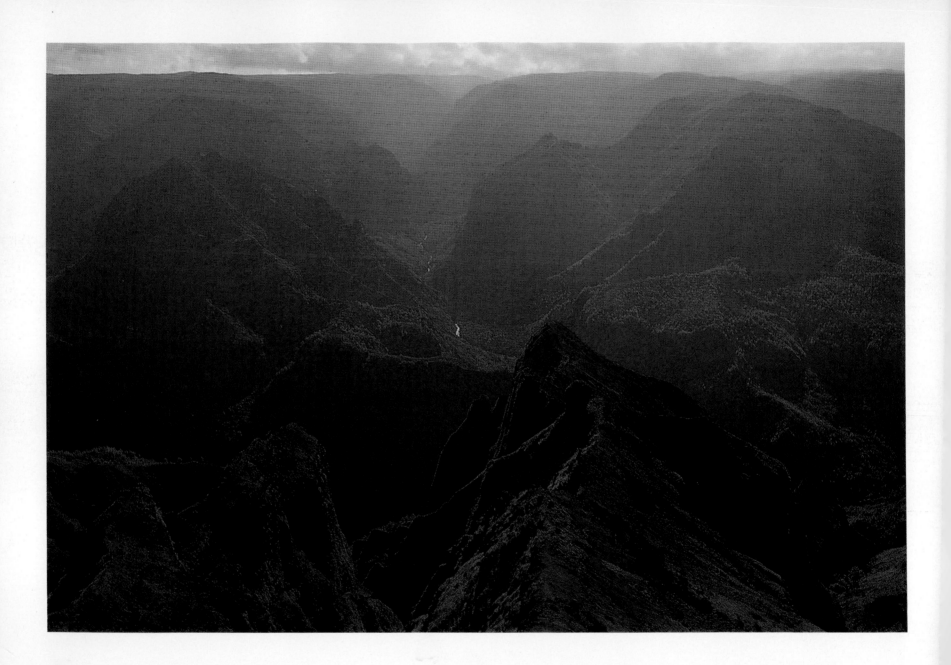

22 Above Waimea Canyon from Puu Hinahina, Kauai

23 *(right)* Venting steam in Kilauea Caldera, Hawaii Volcanoes National Park, Hawaii

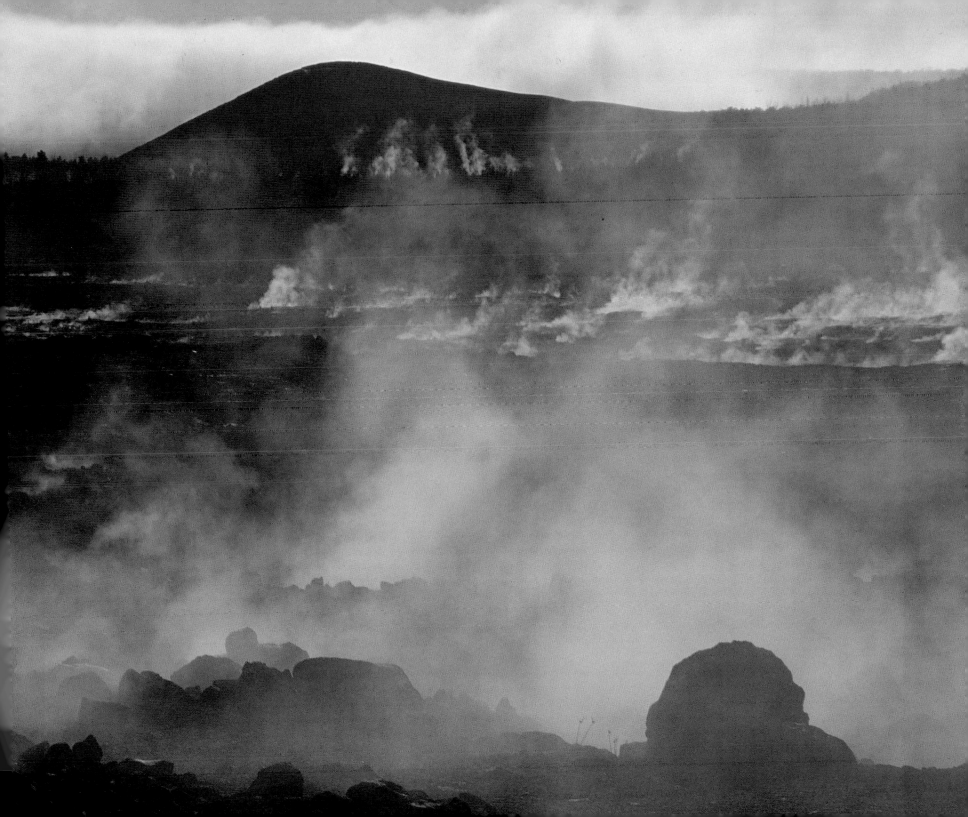

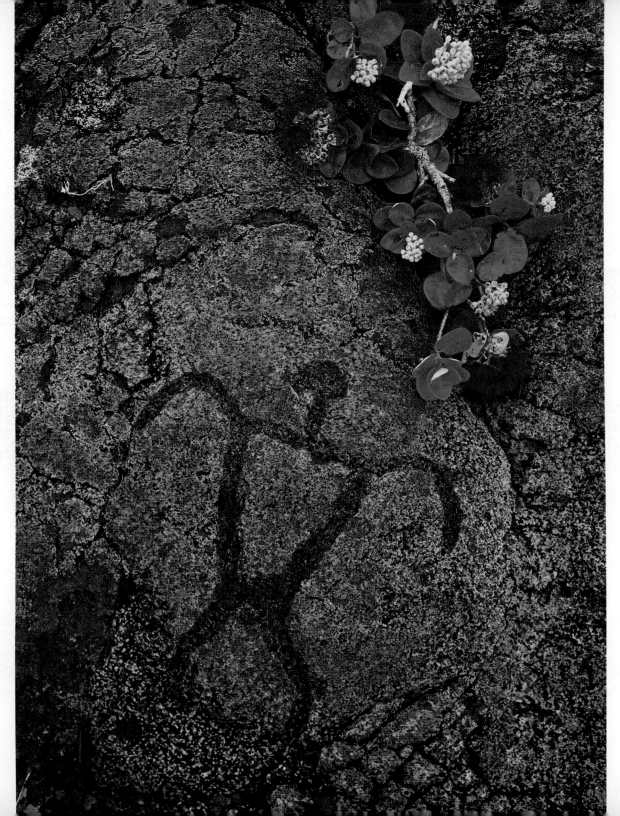

24 Petroglyph of human figure and
ohia-lehua branch, Puuloa Petroglyphs,
Hawaii Volcanoes National Park, Hawaii

25 *(right)* Wooden god-images at Puuhonua
O Honaunau National Historical Park,
Kona Coast, Hawaii

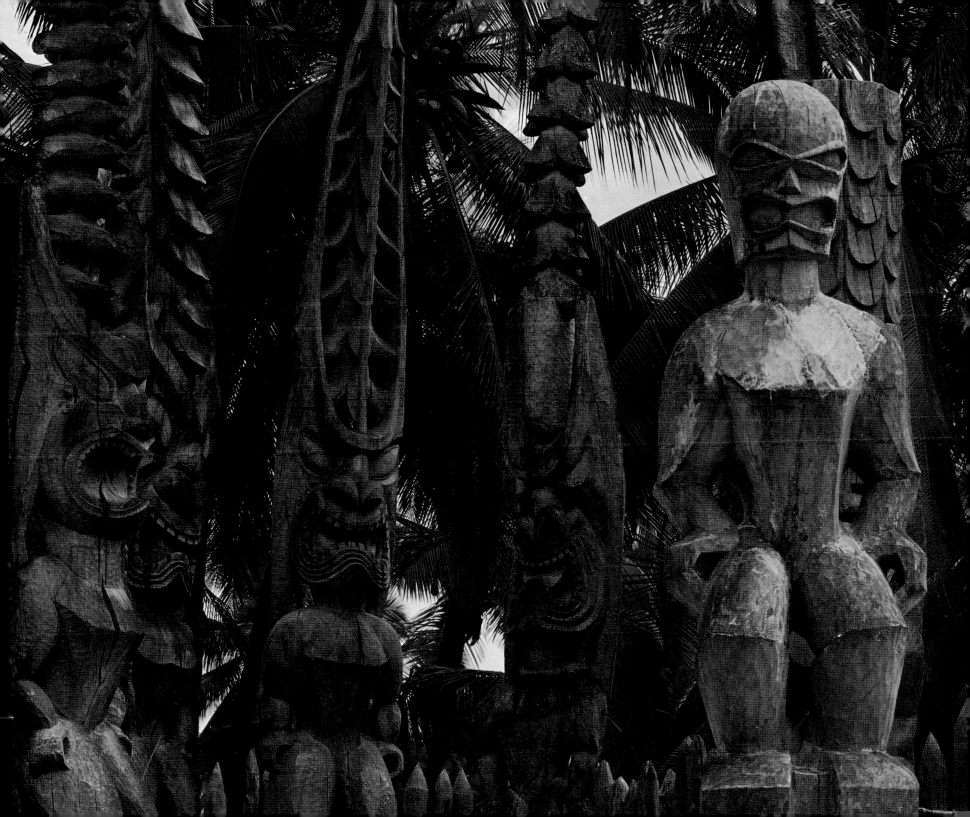

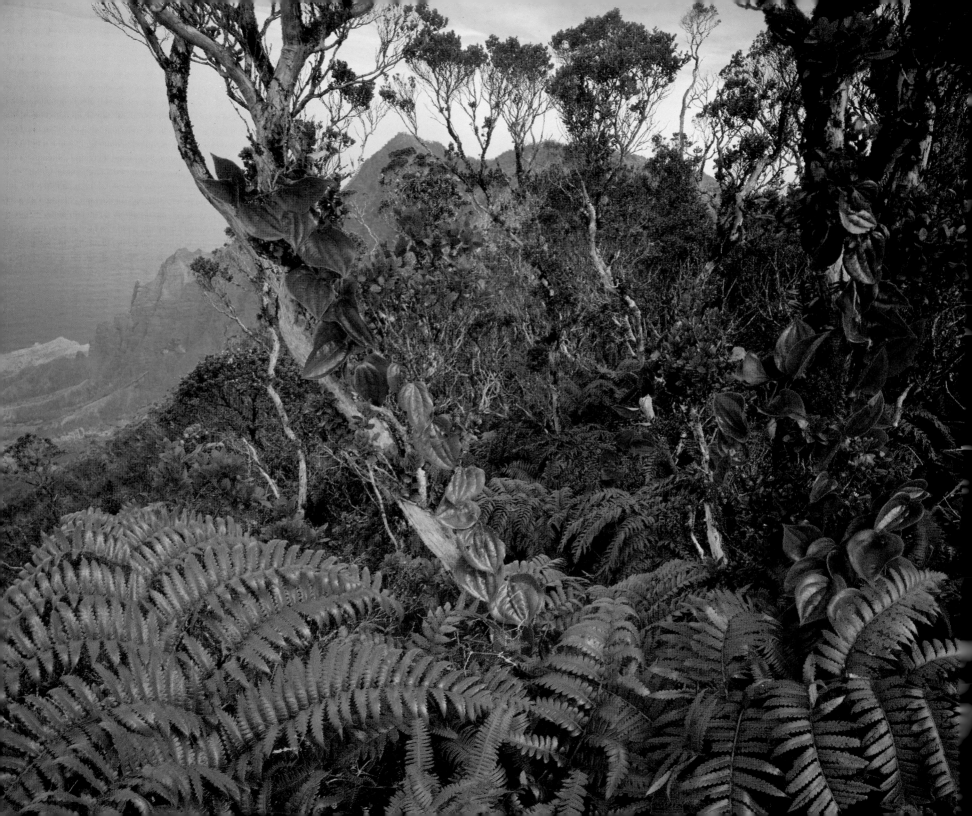

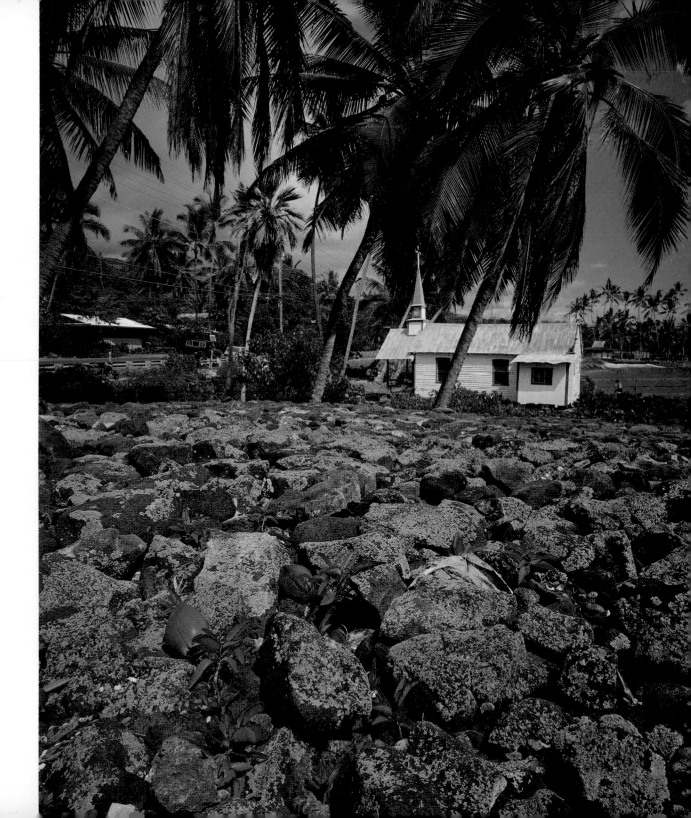

26 *(left)* Hapuu tree fern and ohia on Wainiha Pali, Alakai Swamp, Kauai

27 St Peter's Church and *heiau* (ancient temple), Kona Coast, Hawaii

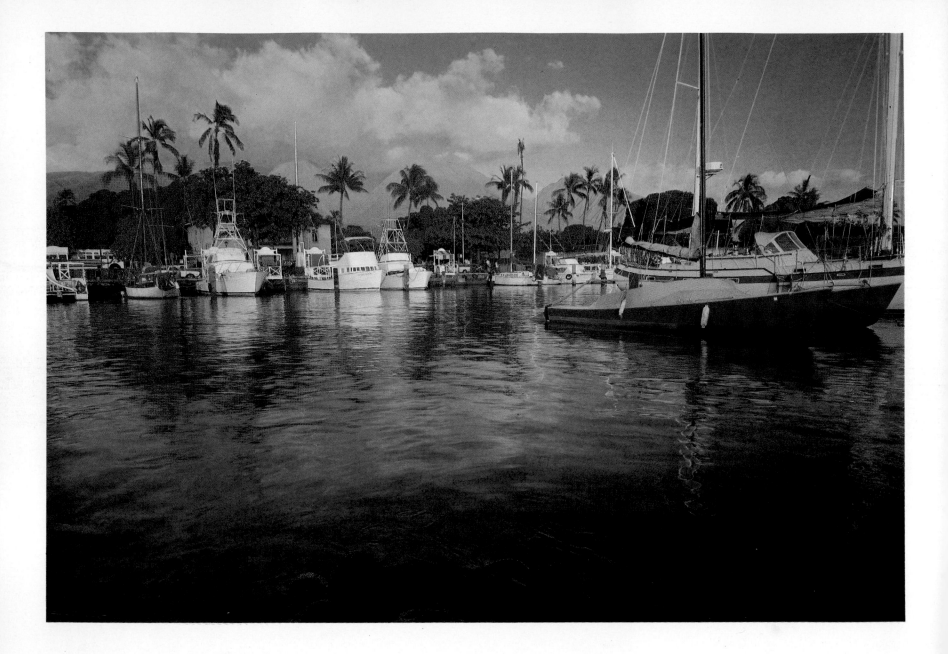

28 Lahaina yacht basin, West Maui

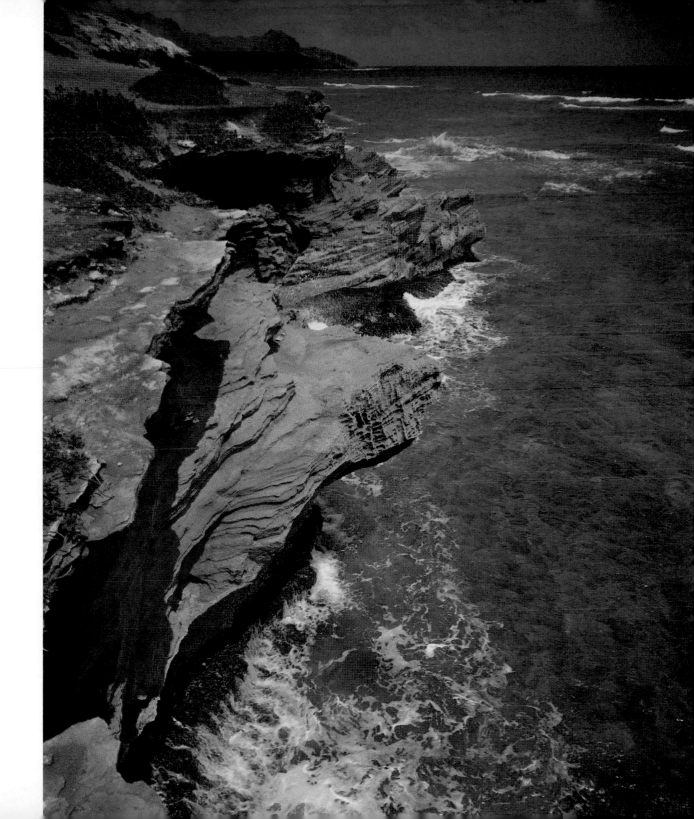

29 Makawehi Bluff, Poipu, Kauai

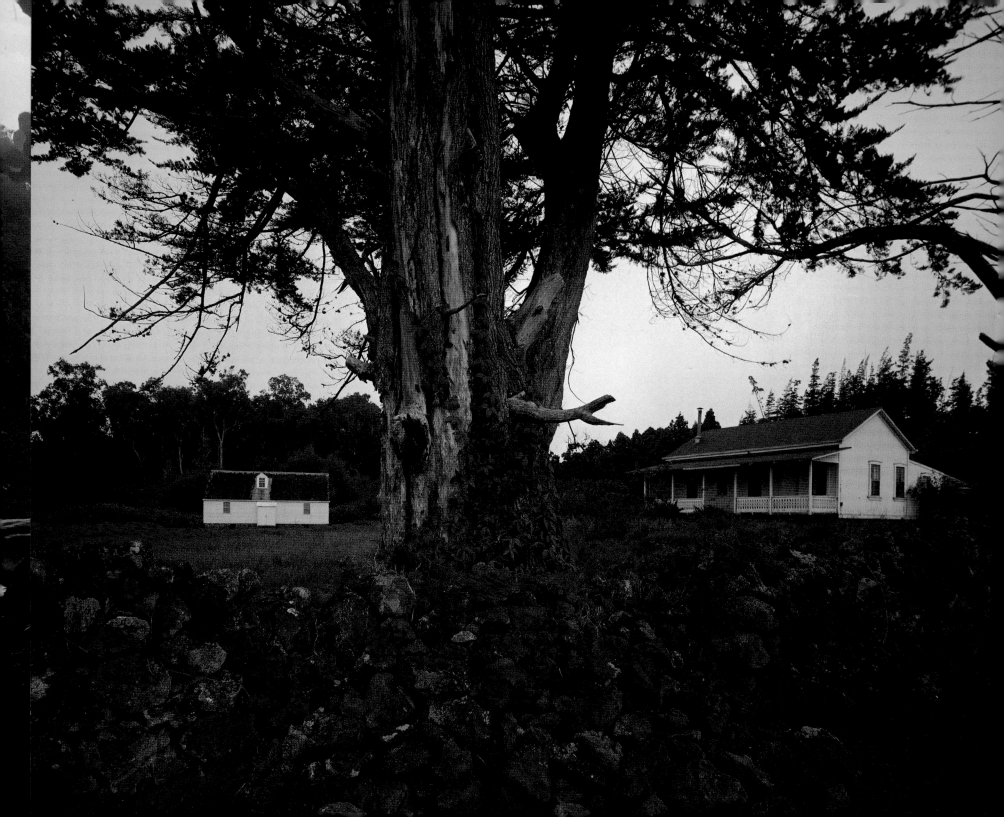

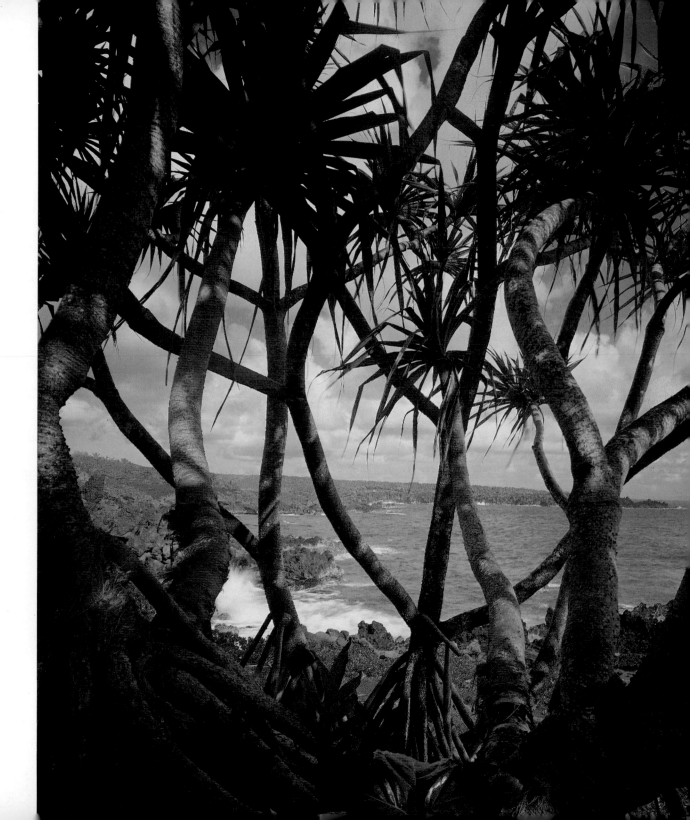

32 (left) Monterey cypress and rockwall,
Parker ranch house, Waimea, Hawaii

33 Pu-hala (screwpine) Waianapanapa
Bay, Hana Coast, Maui

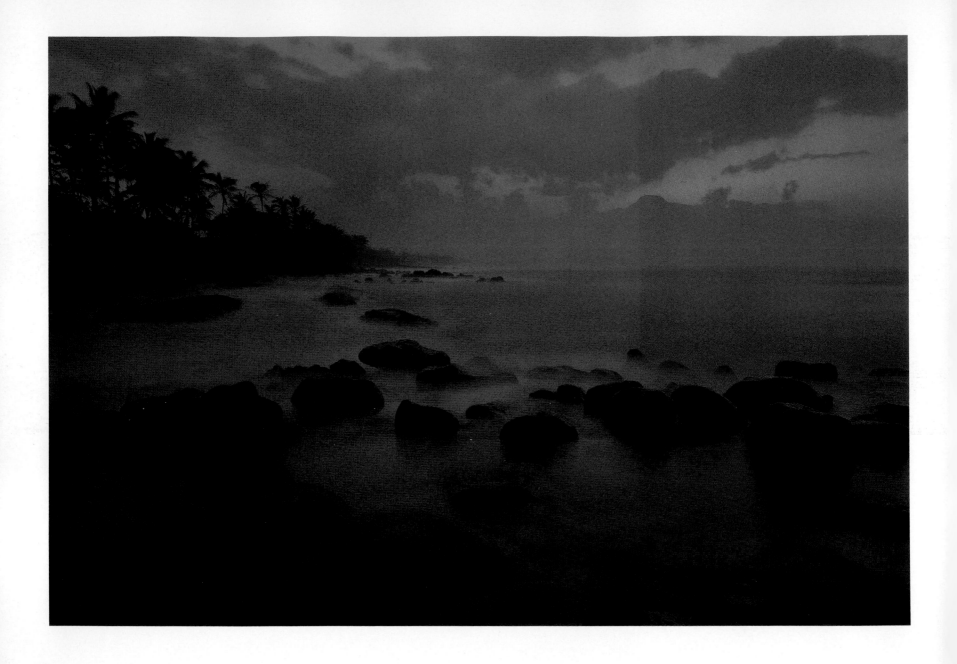

·34 Evening surf and West Maui Mountains at H.P. Baldwin Park, Maui

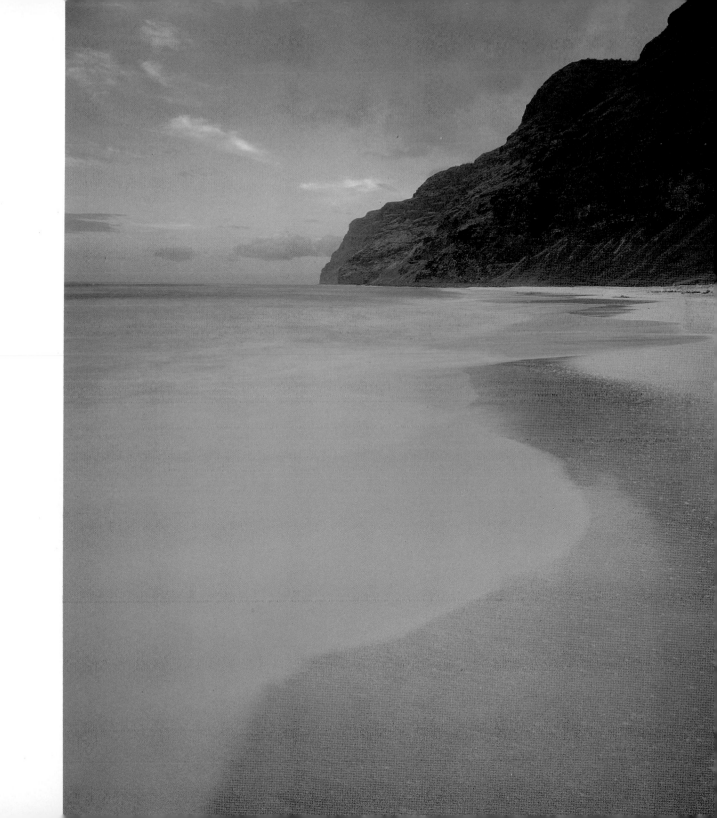

35 Gentle surf and Na Pali Coast,
Barking Sands Beach, Kauai

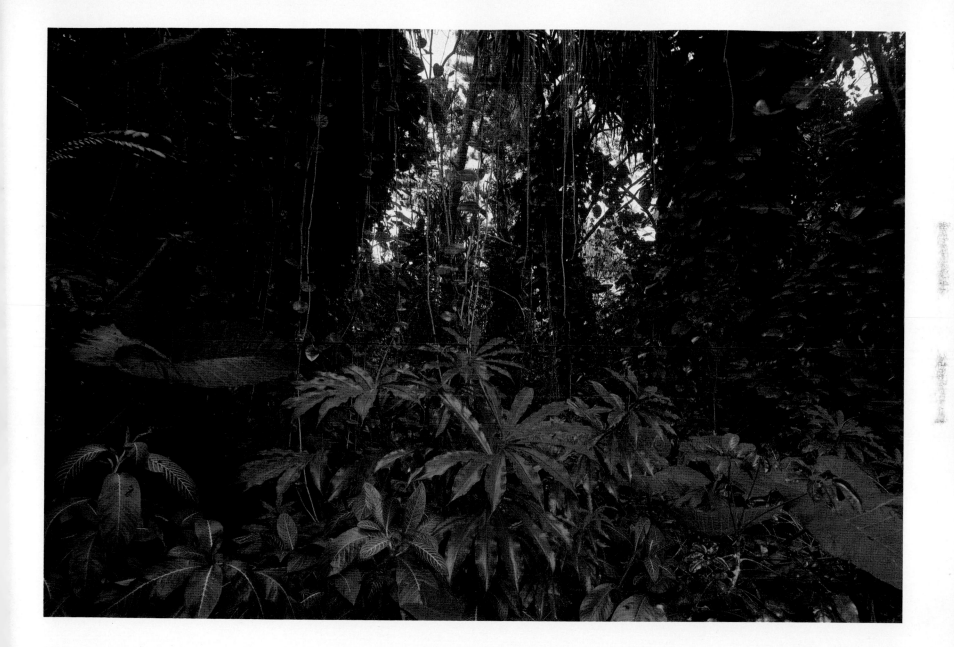

36 *(left)* Kilauea Caldera, Mauna Loa, Hawaii

37 Rain-forest plant mix in Manoa Valley, Koolau Range, Oahu

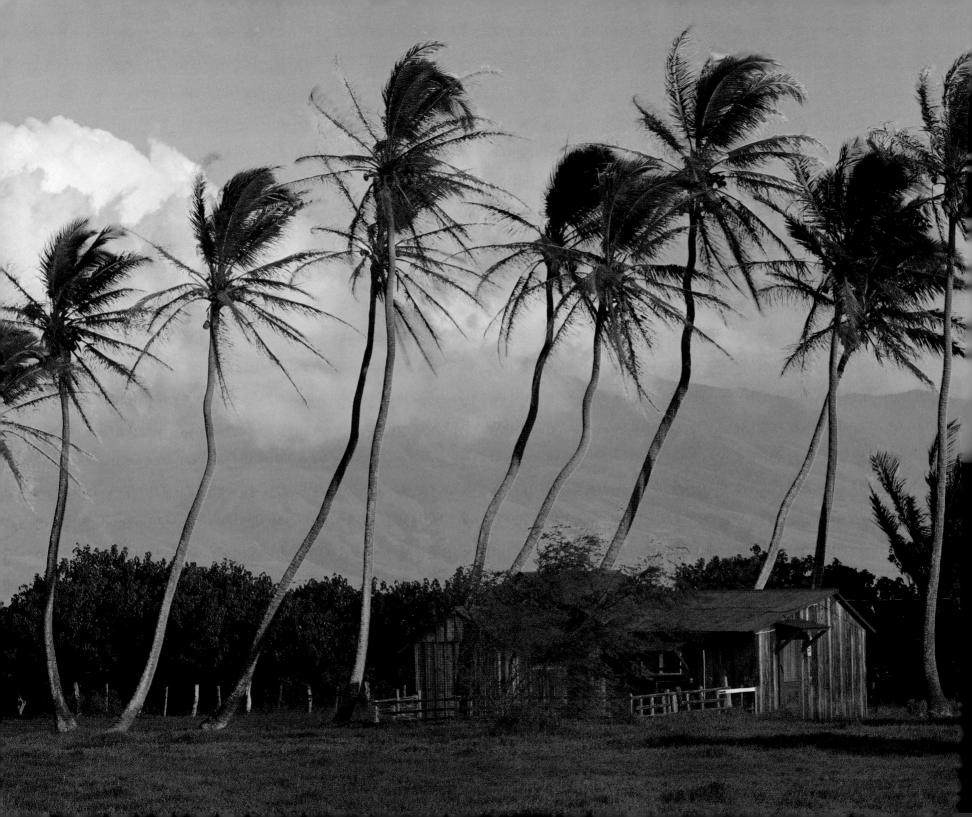

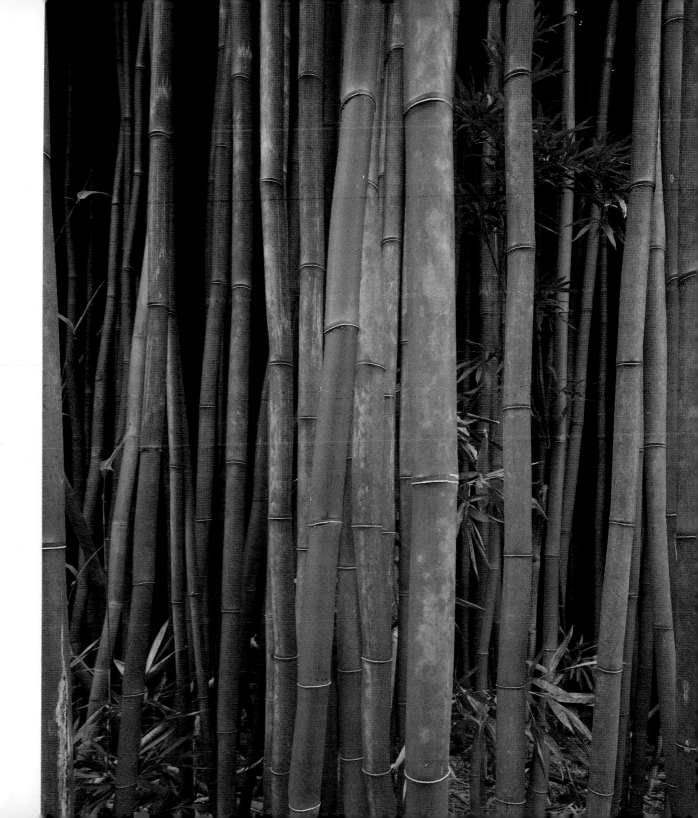

38 *(left)* Wind-battered coco palms and
homestead on East Molokai, with West
Maui Mountains behind, Molokai

39 Bamboo grove, Pipiwai Stream,
Haleakala National Park, East Maui

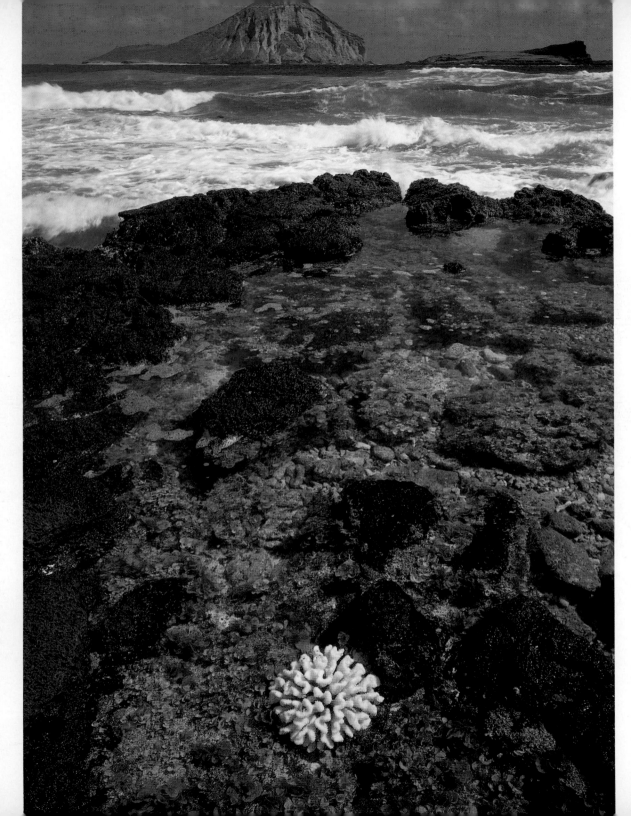

40 Coral and tidal pool with Manana and
Kaohikaipu Islands offshore, Makapuu
Point, Oahu

41 *(right)* Kapuaiwa Royal Coconut
Grove at Kaunakakai, Molokai

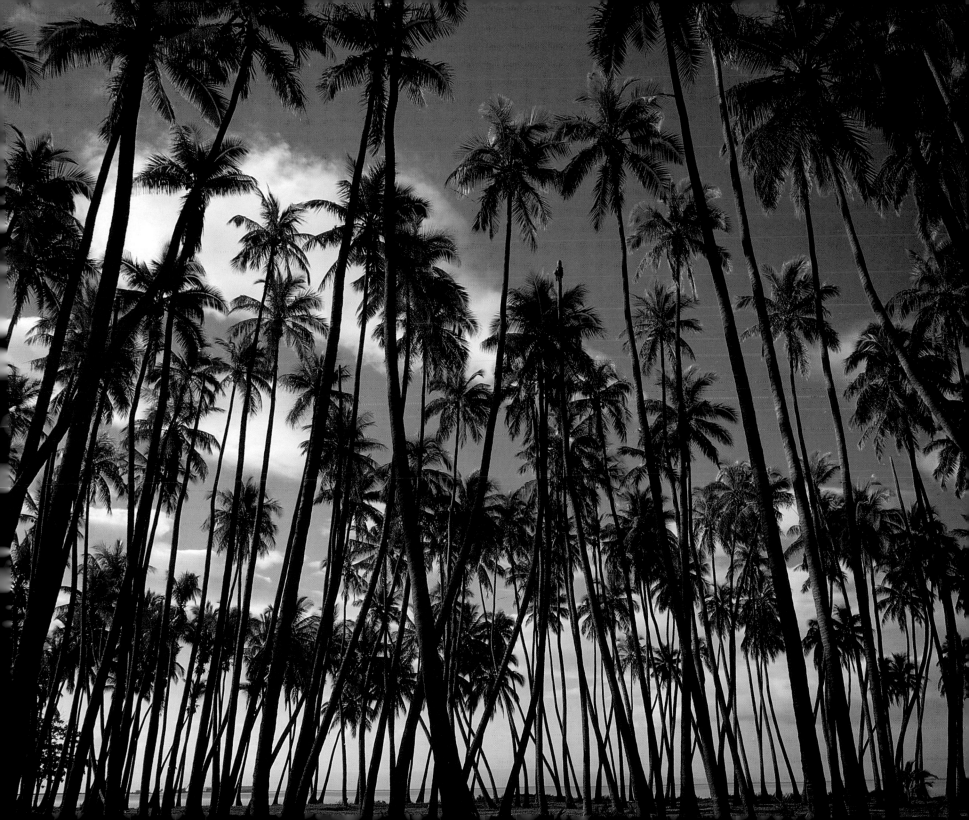

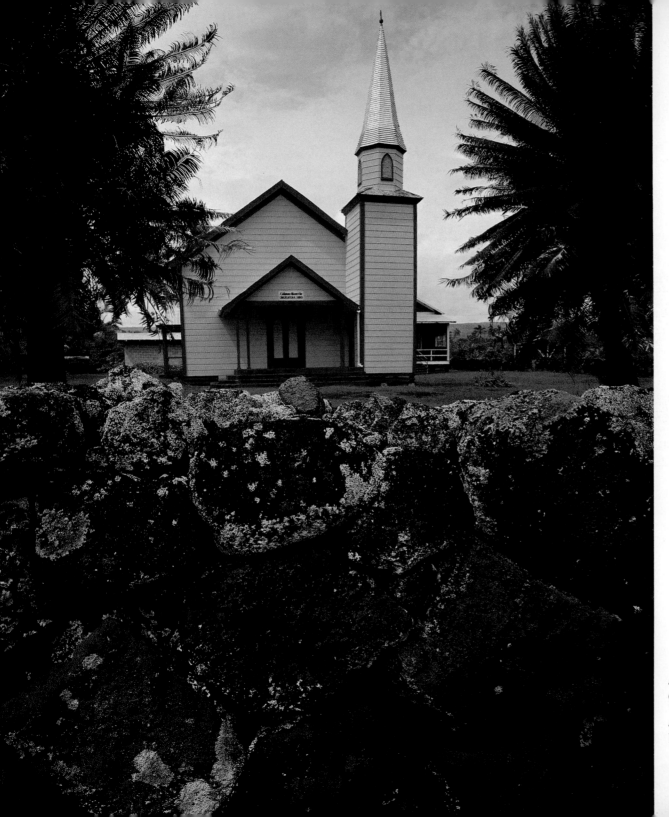

42 Kalapana-Mauna Kea Congregational
Church, Hawaii

43 *(right)* Kiawe trees and makua,
Barking Sands Beach, Waianae, Oahu

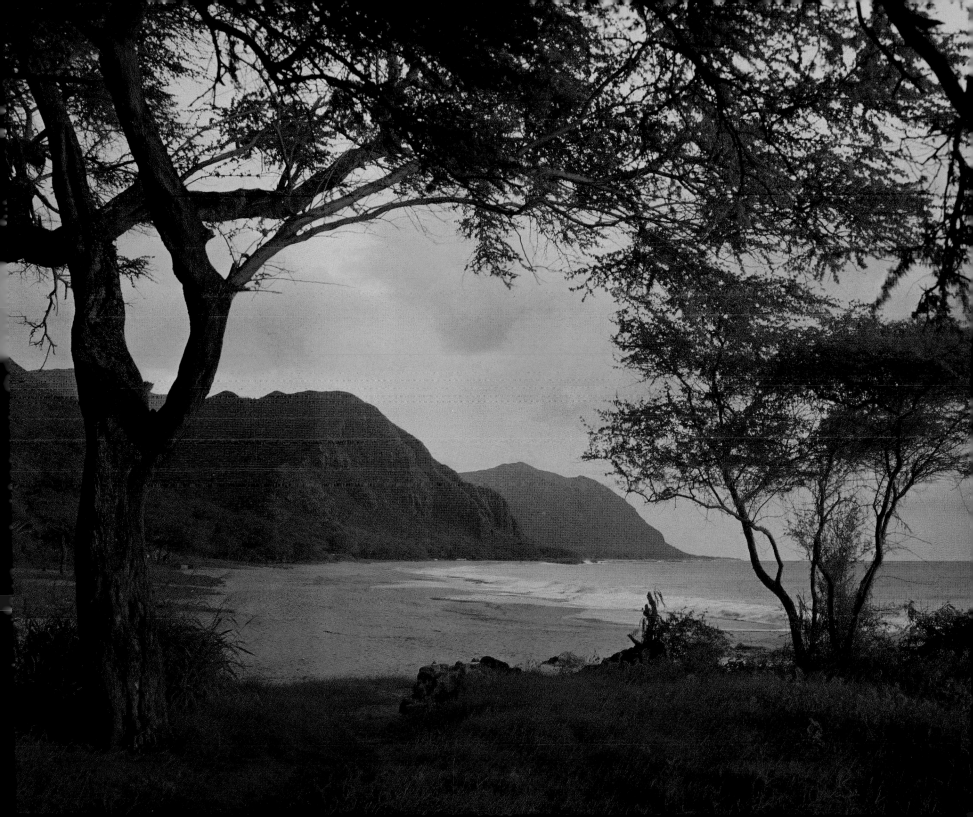

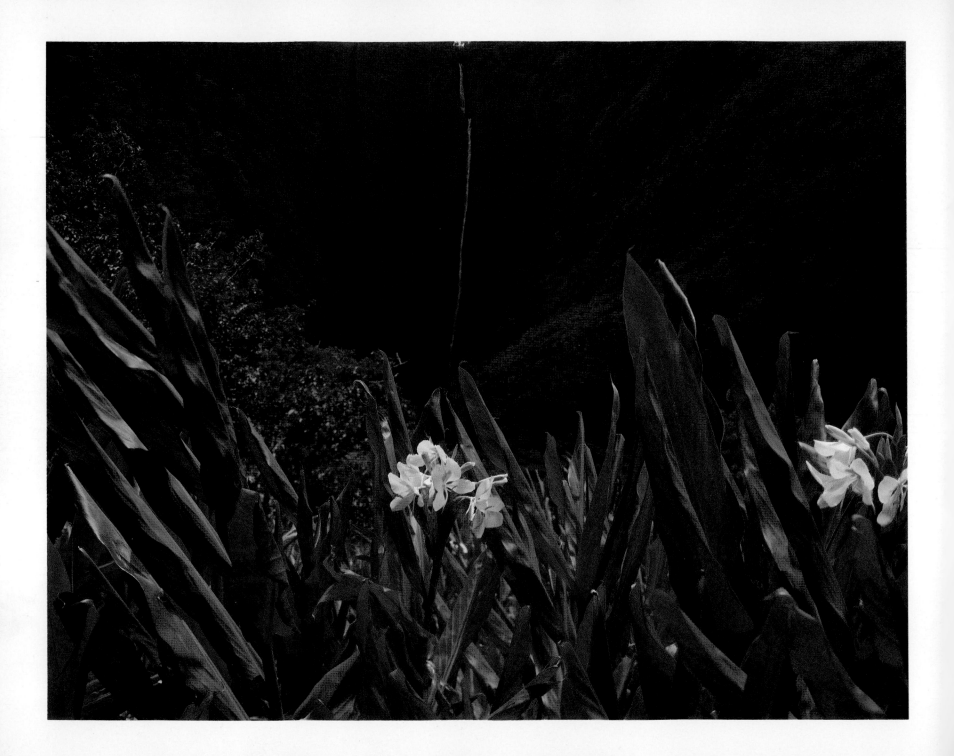

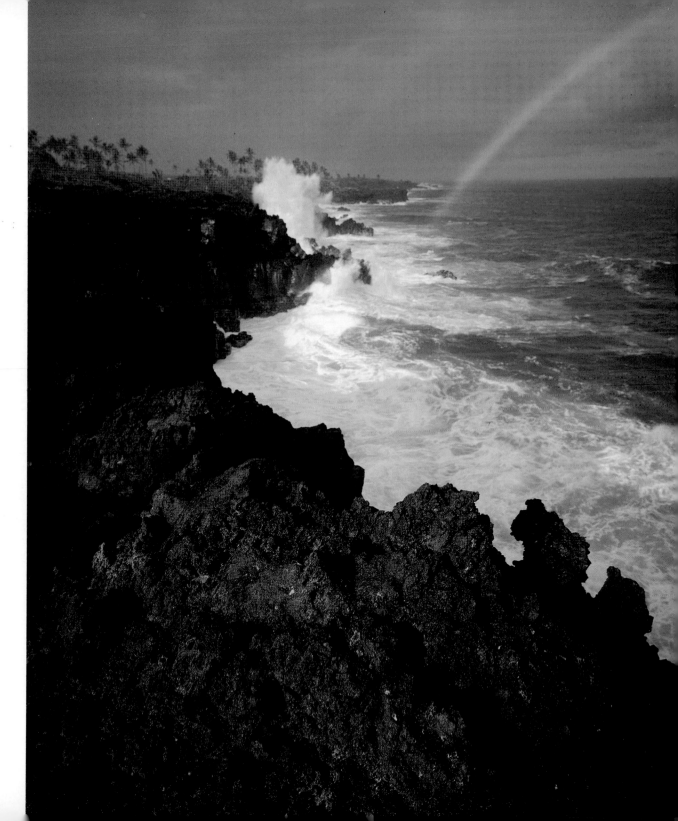

44 *(left)* Ginger and the twin waterfalls of Hiilawe, Waipio Valley, Hawaii

45 Windward storm on Kalapana Coast—Wahaula *heiau* site, Hawaii Volcanoes National Park, Hawaii

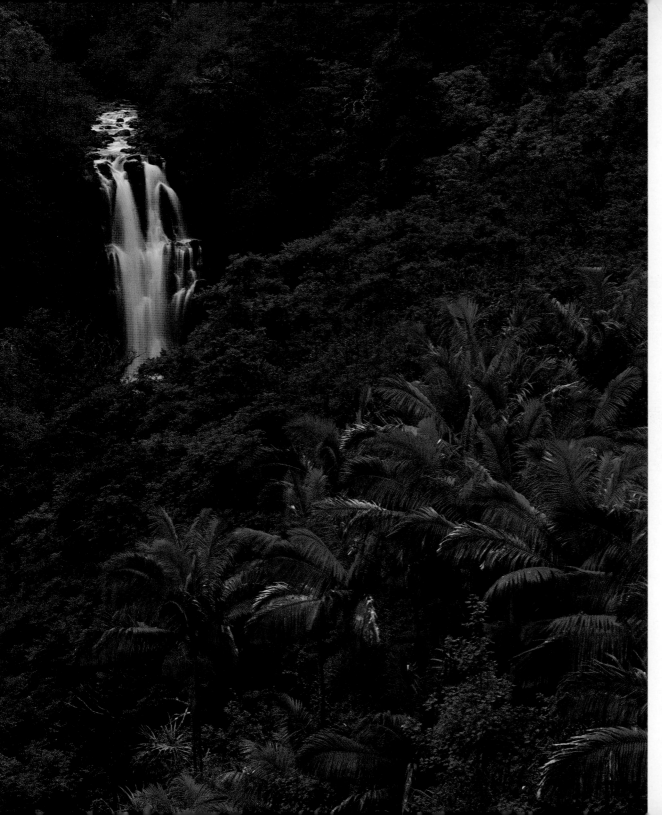

46 Waterfall along Hamakua Coast, Windward Hawaii

47 *(right)* Taro crop in Hanalei Valley, Kauai

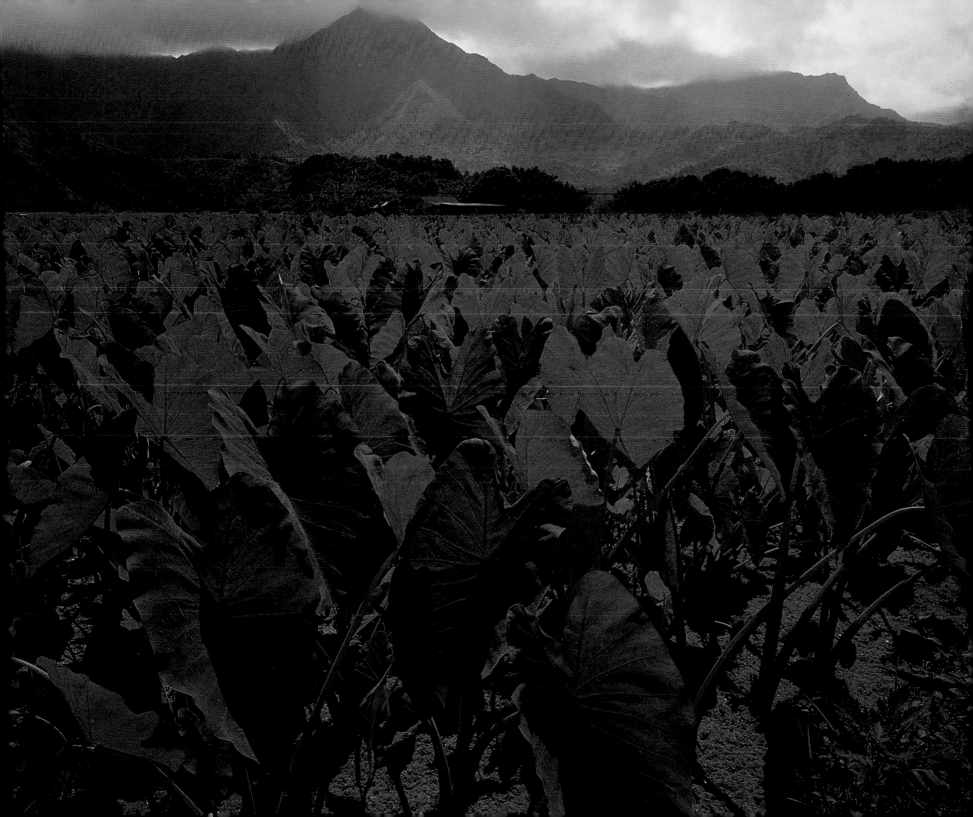

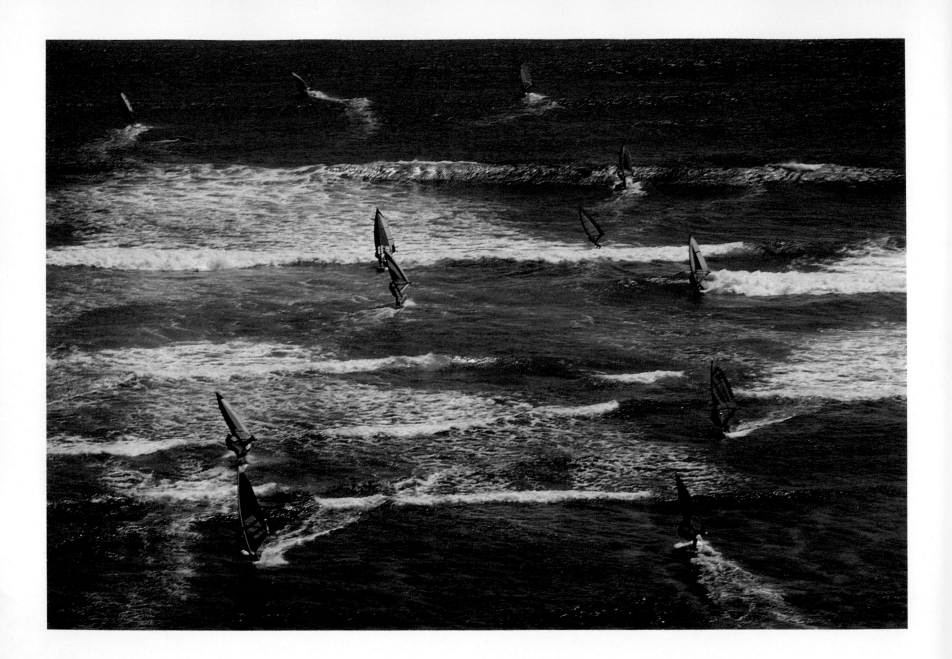

48 Wind surfing off Diamond Head, Oahu

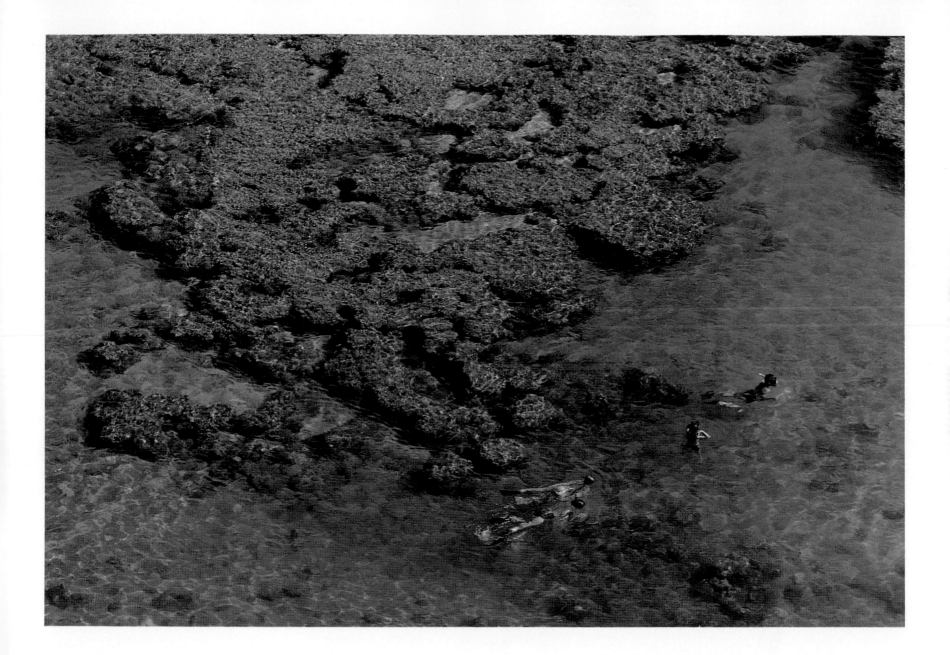

49 Snorkeling in coral reef off Hanauma Bay, Oahu

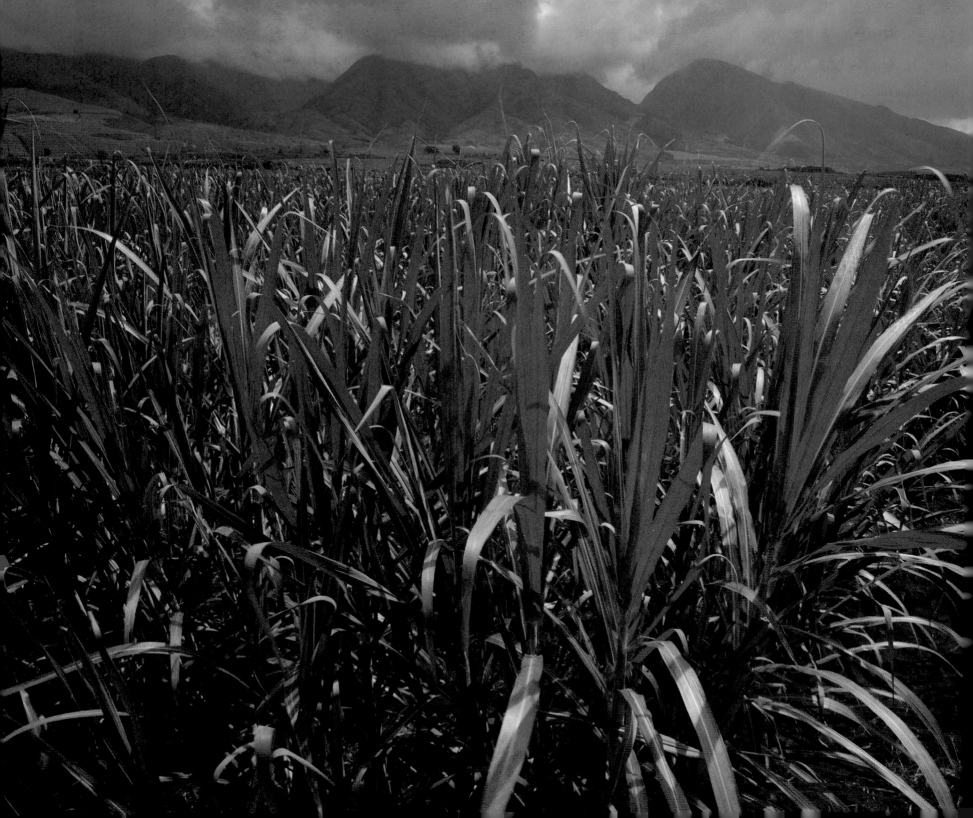

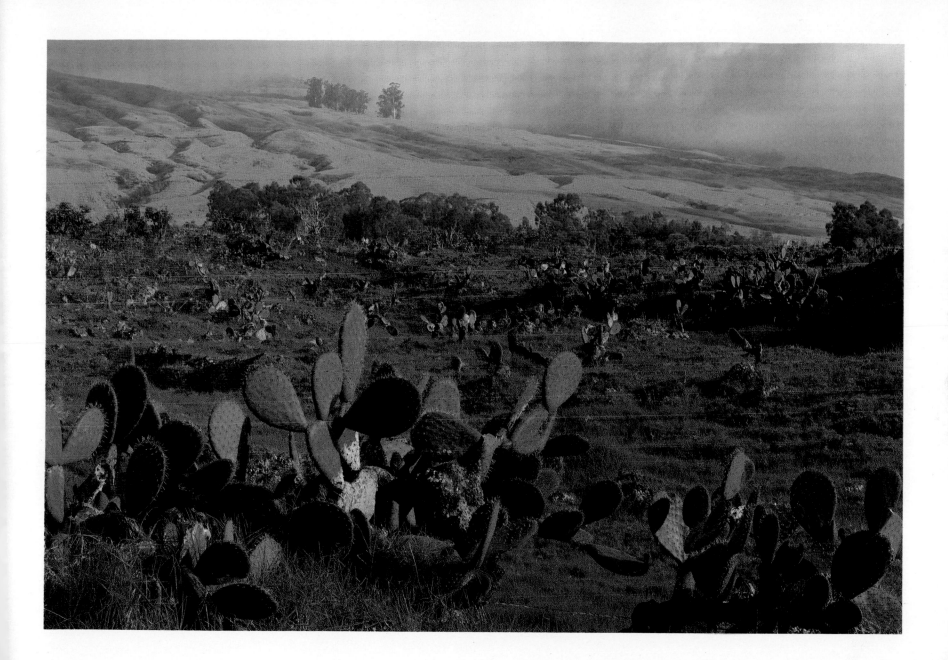

50 *(left)* Mature sugar cane and West Maui Mountains

51 Up-country pastures on Haleakala with prickly-pear cacti and eucalyptus, Ulupalakua Ranch, Maui

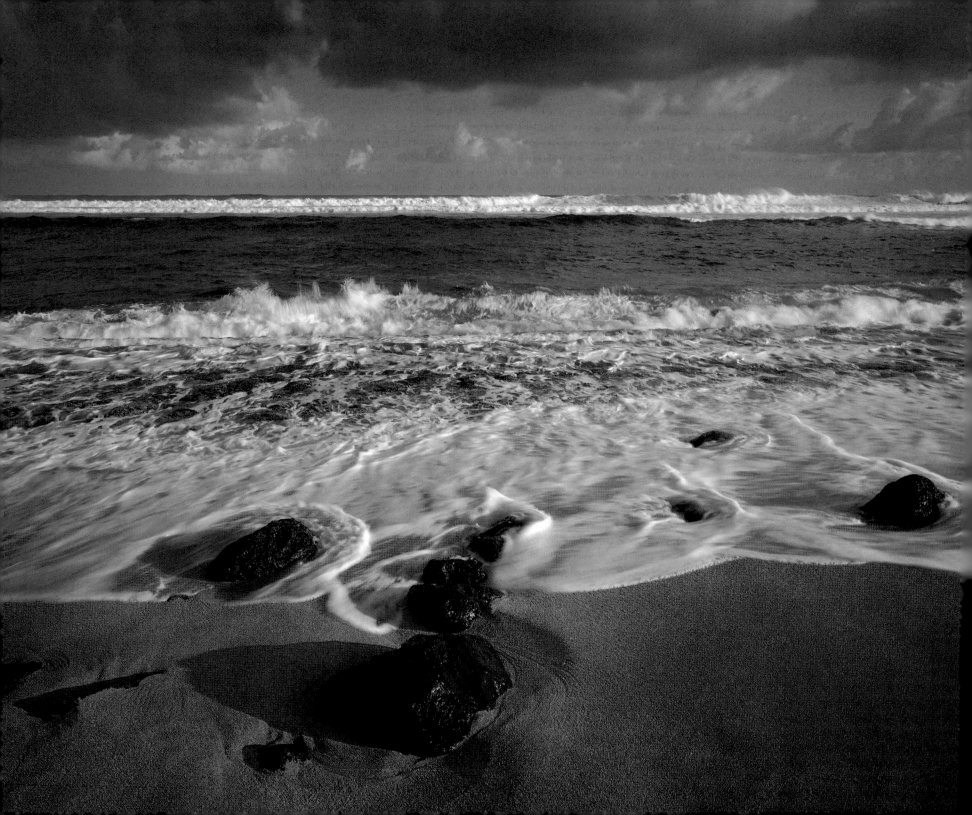

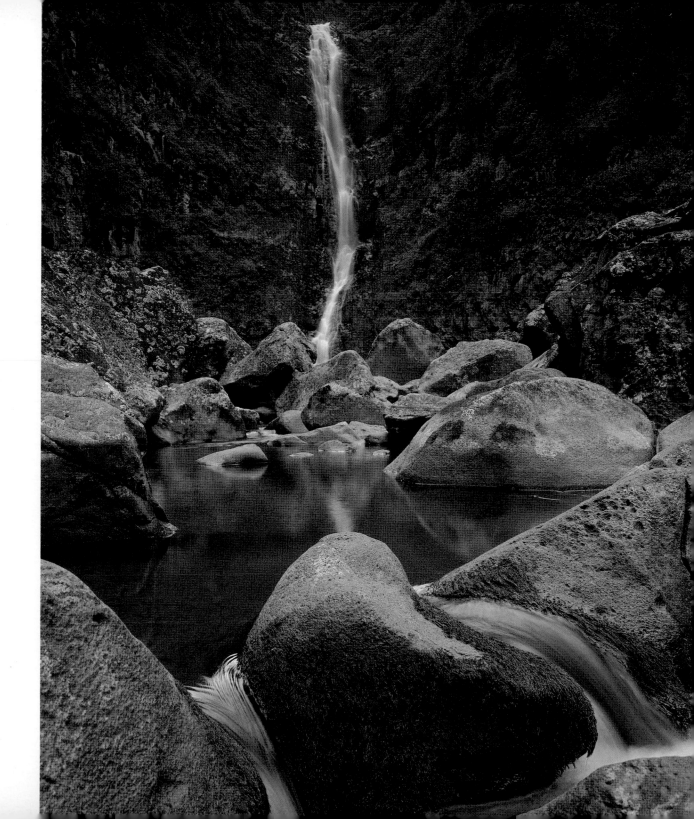

52 *(left)* Morning surf and reef off Hookipa Beach, Maui

53 Lower Moaula Falls and pools in Halawa Valley, Molokai

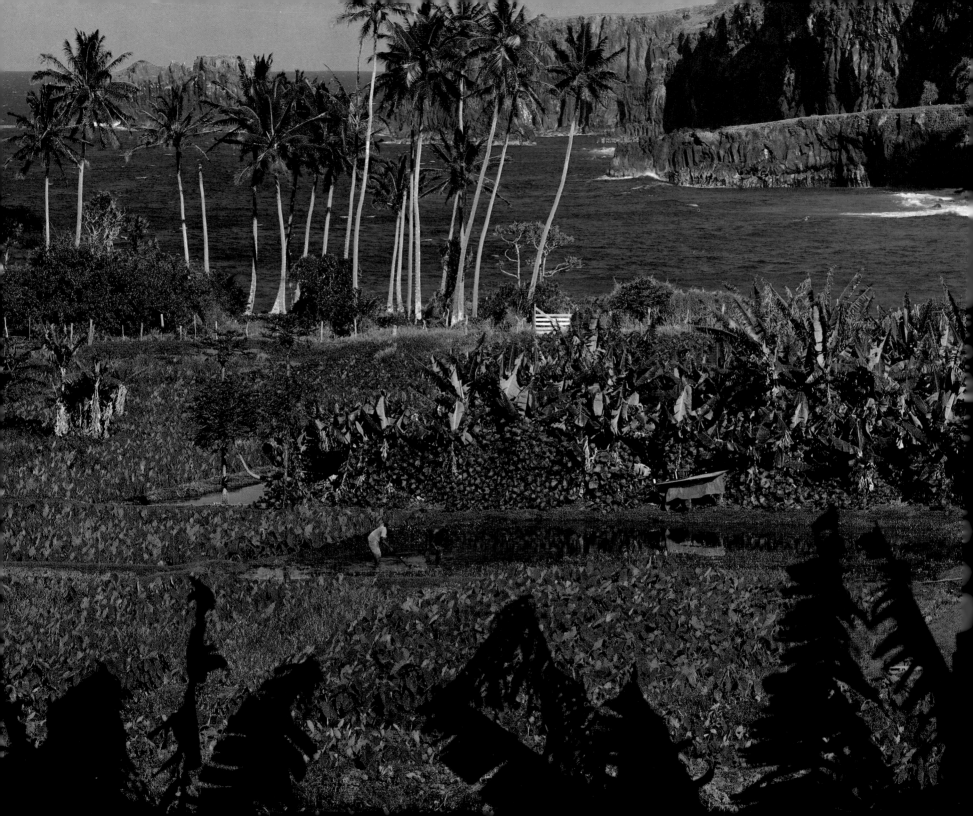

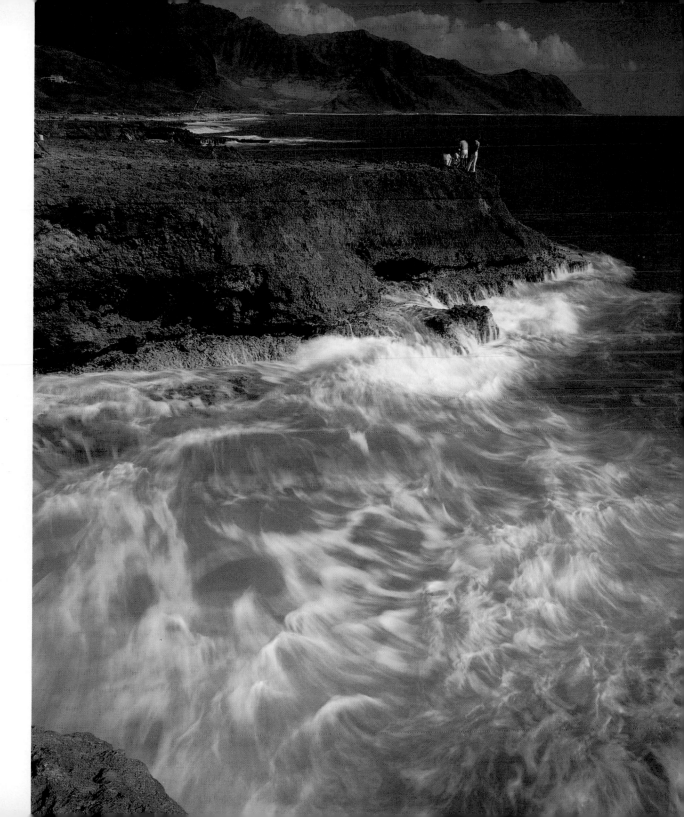

54 *(left)* Keanae Peninsula, taro fields and bananas, Hana Coastline, Maui

55 Volcanic headlands in Makua-Kaena State Park, Leeward Oahu

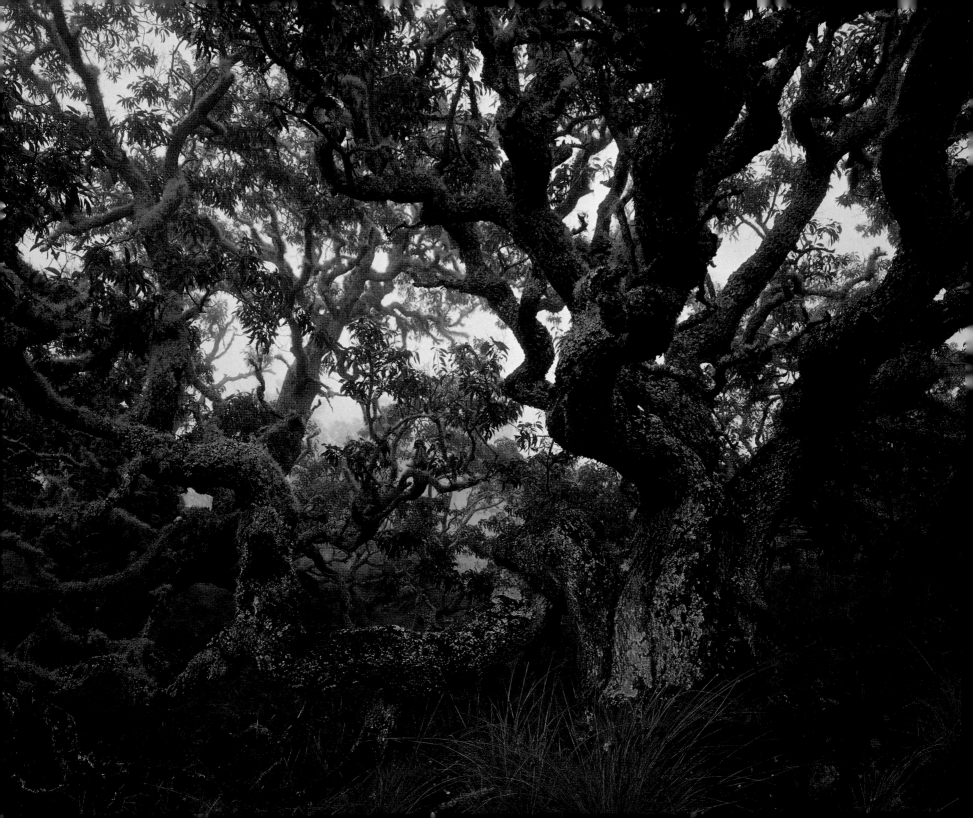

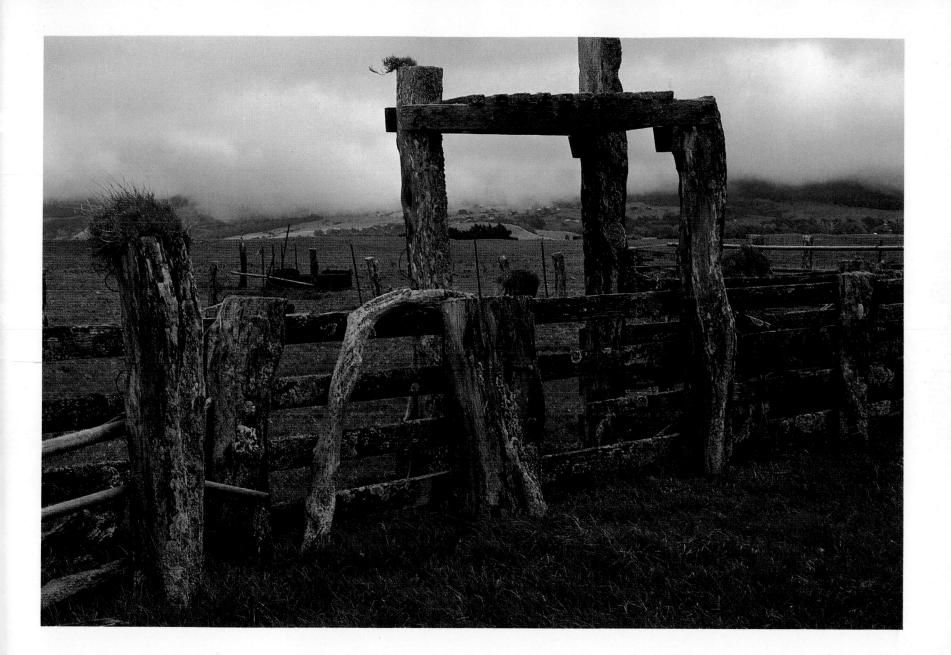

56 *(left)* Large acacia koa grove along the Mauna Loa road,
Hawaii Volcanoes National Park,

57 Weathered corral on the Parker Ranch, Hawaii

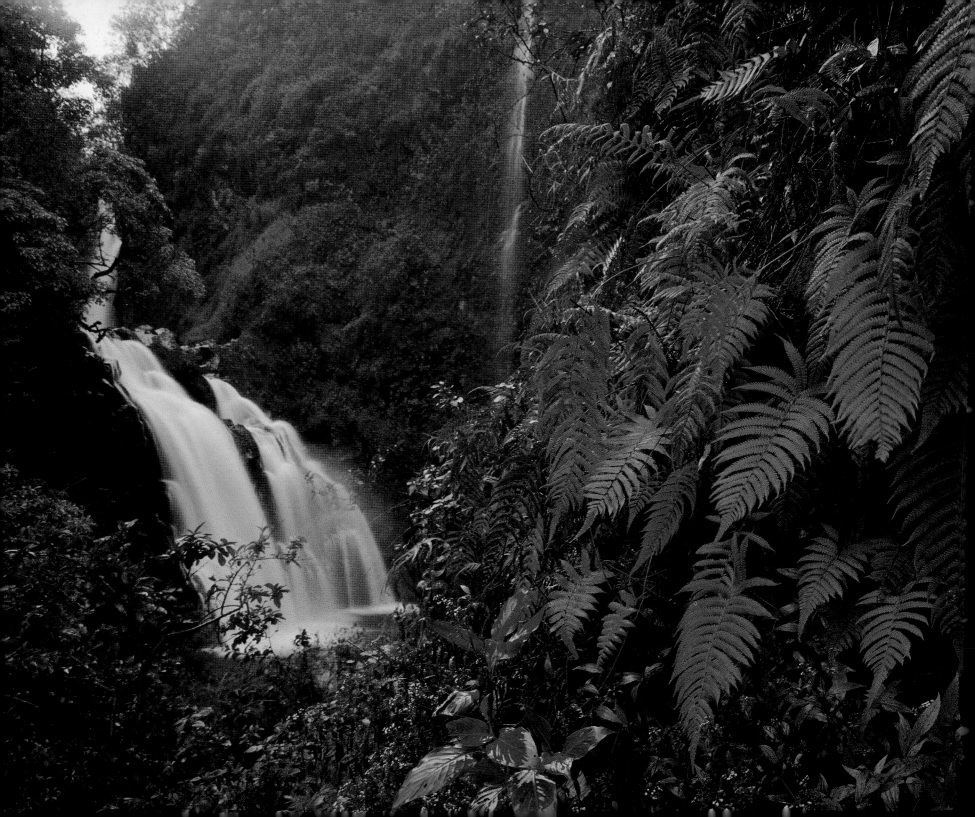

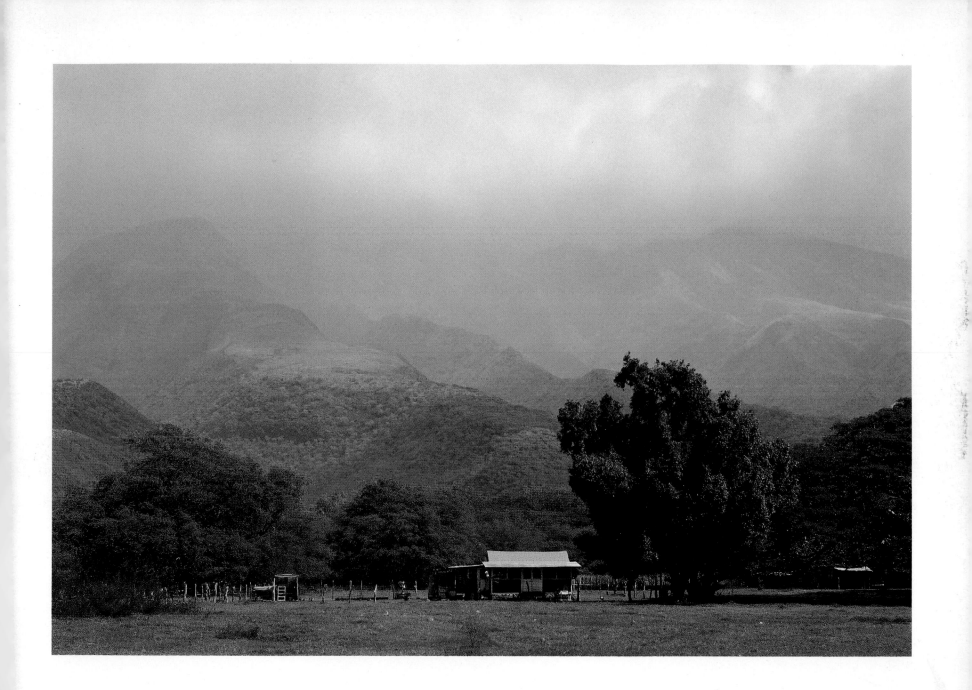

58 *(left)* Kopiliula Falls and palapalai fern on the Hana road, East Maui

59 Homestead below eroded Kamakou Mountain on East Molokai

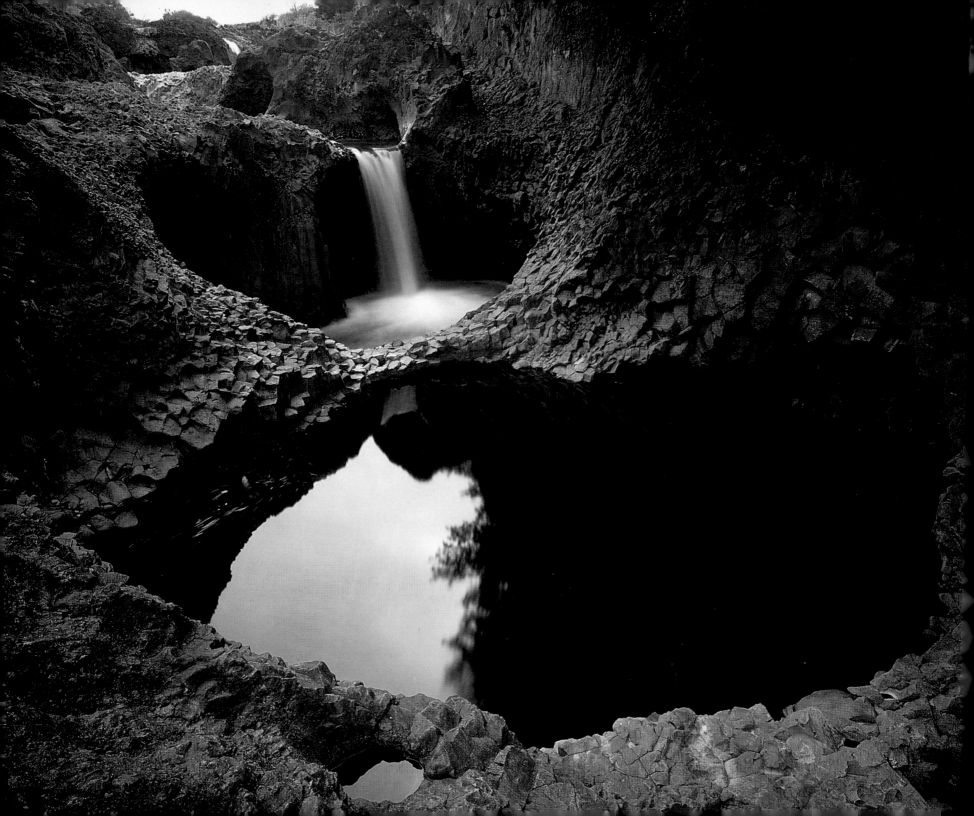

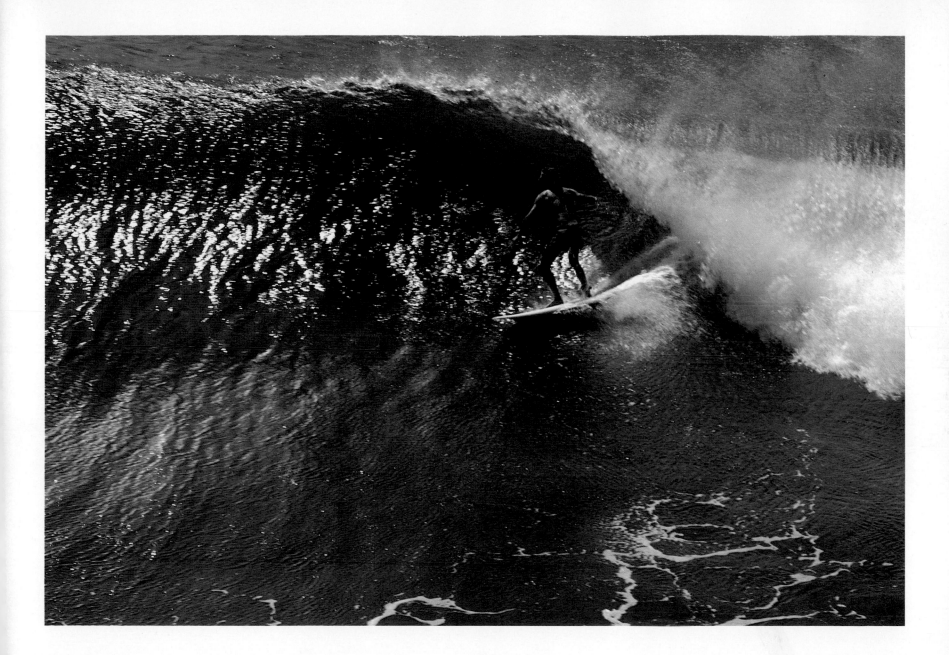

60 *(left)* Boiling pots in the Wailuku River above Hilo, Hawaii

61 Surfing a wave off Lipoa Point, West Maui

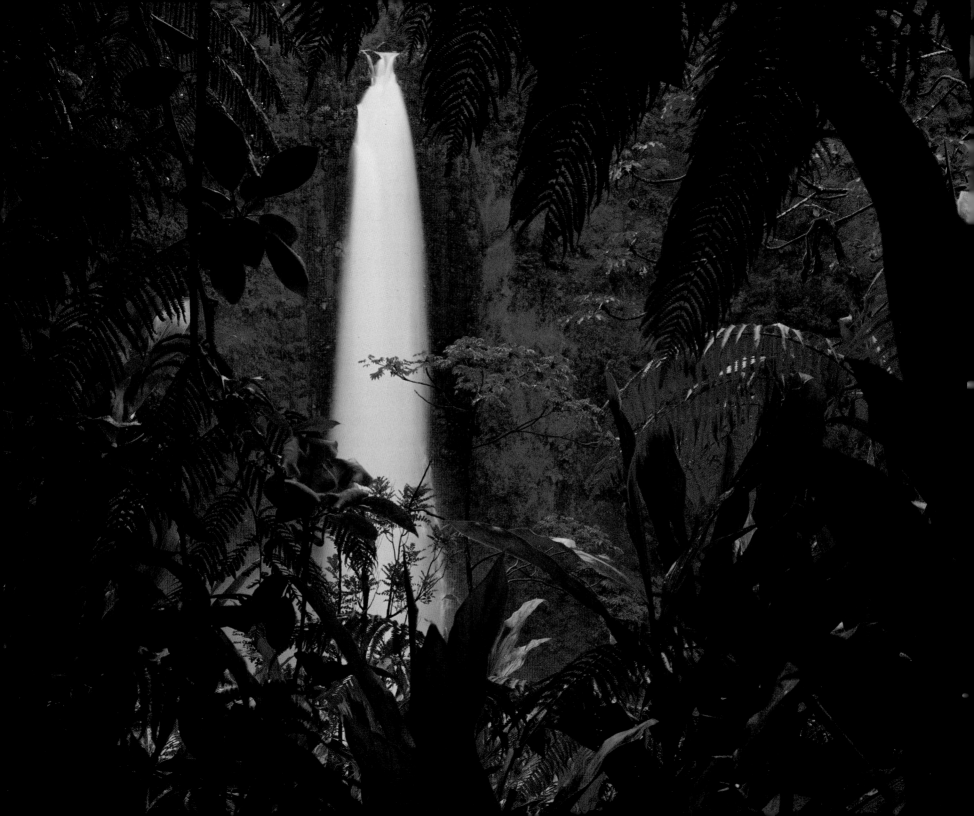

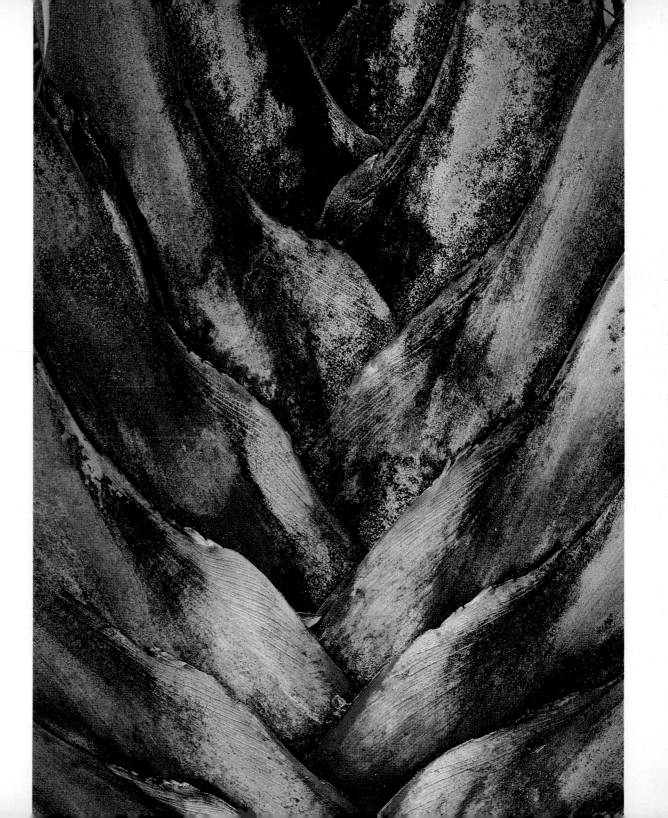

62 *(left)* Akaka Falls in rain forest of Hamakua Coastline, Hawaii

63 Traveller's palm, in Olu Pua Botanical Gardens, Kauai

64 Petroglyph of human figures on a lava flow at Puako, North Kona Coast, Hawaii

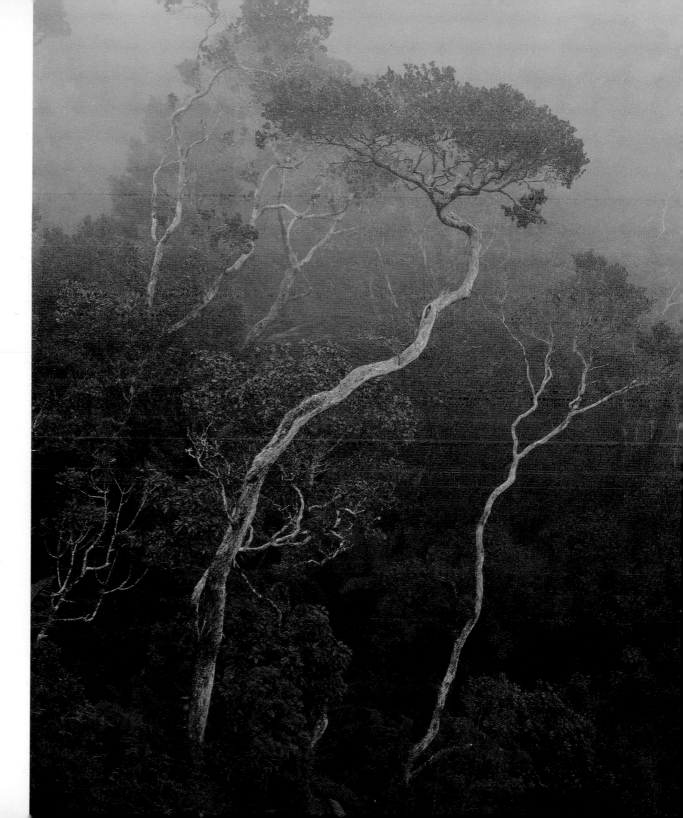

65 Contorted ohia trees on Wainiha Pali,
Alakai Swamp, Kauai

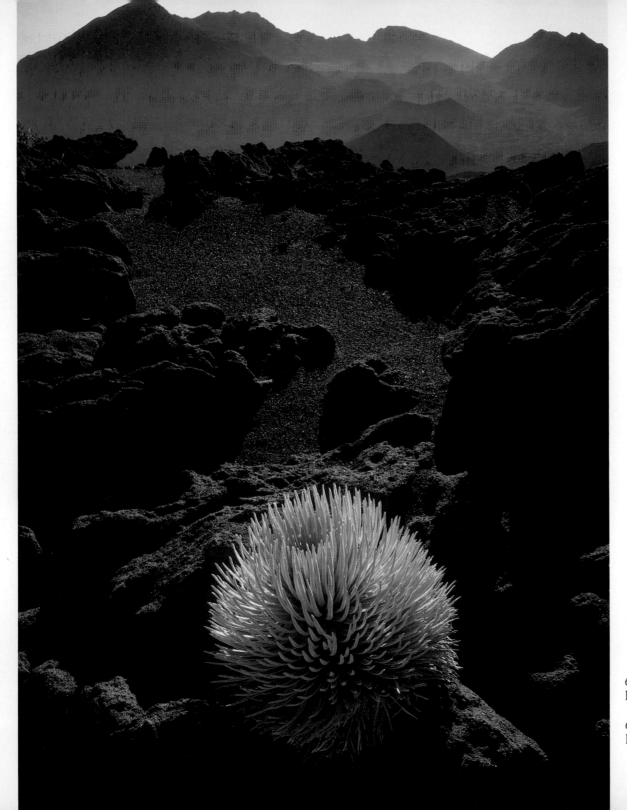

66 Young silversword on rim of
Haleakala Crater, Maui

67 *(right)* Morning tidal pool and surf at
Hookipa Beach Park, Maui

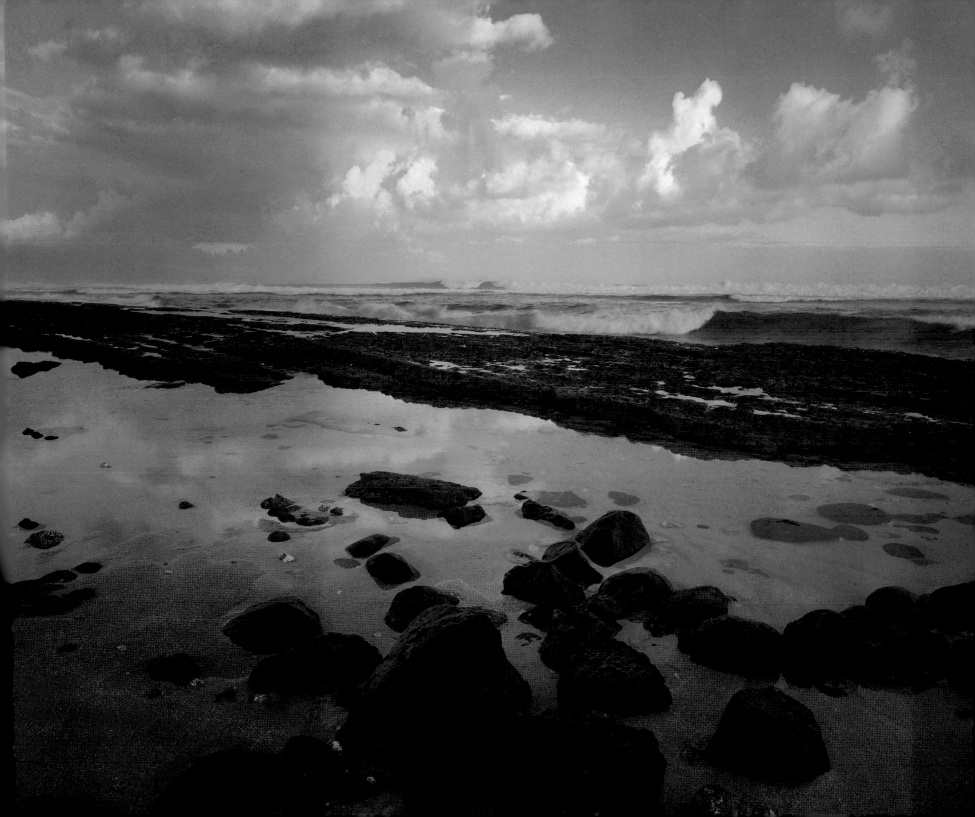

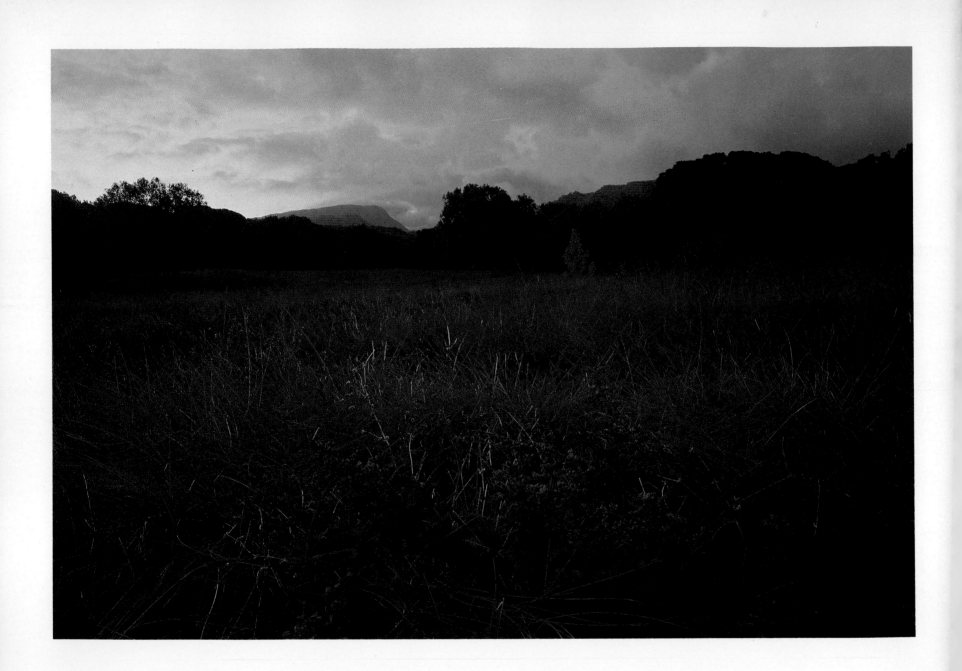

68 Evening moods in Kipahulu Valley with mountain rose, Haleakala National Park, Maui

69 *(right)* Ginger and Rainbow Falls on the Wailuku River, Hilo, Hawaii

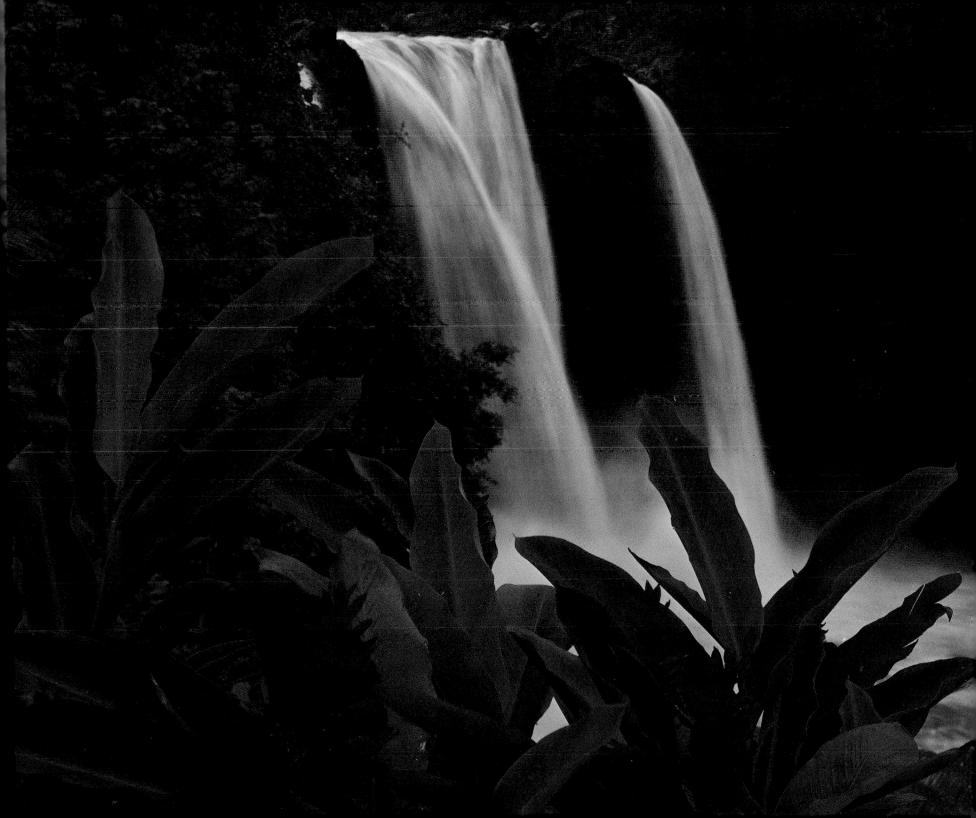

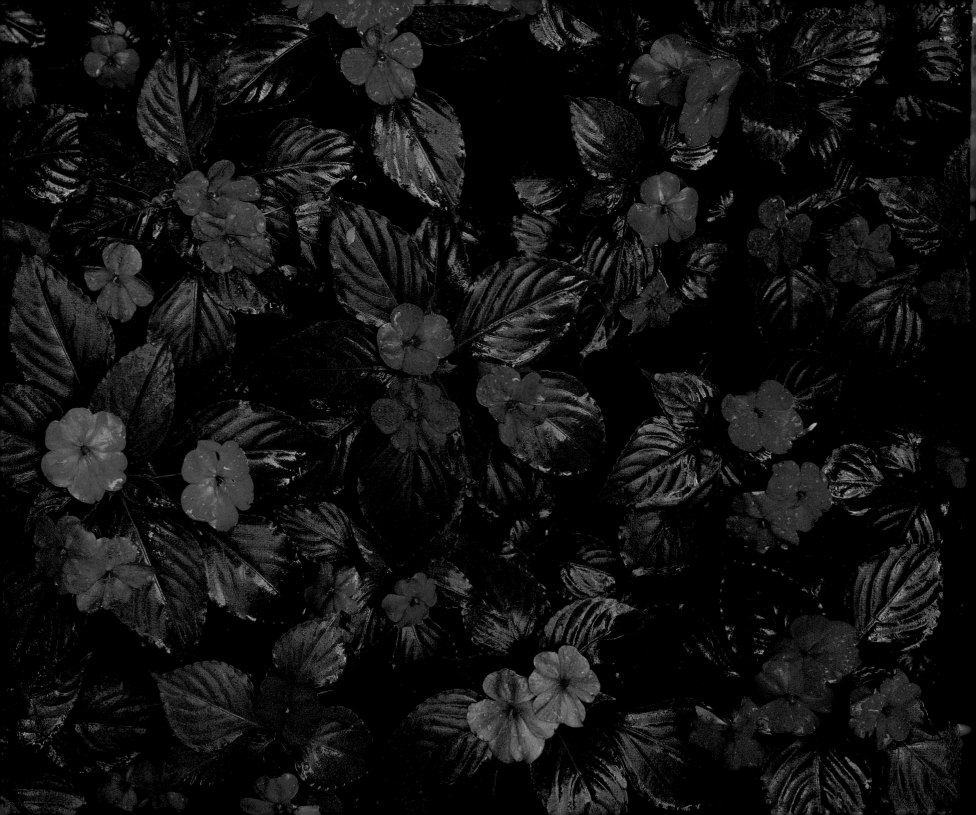

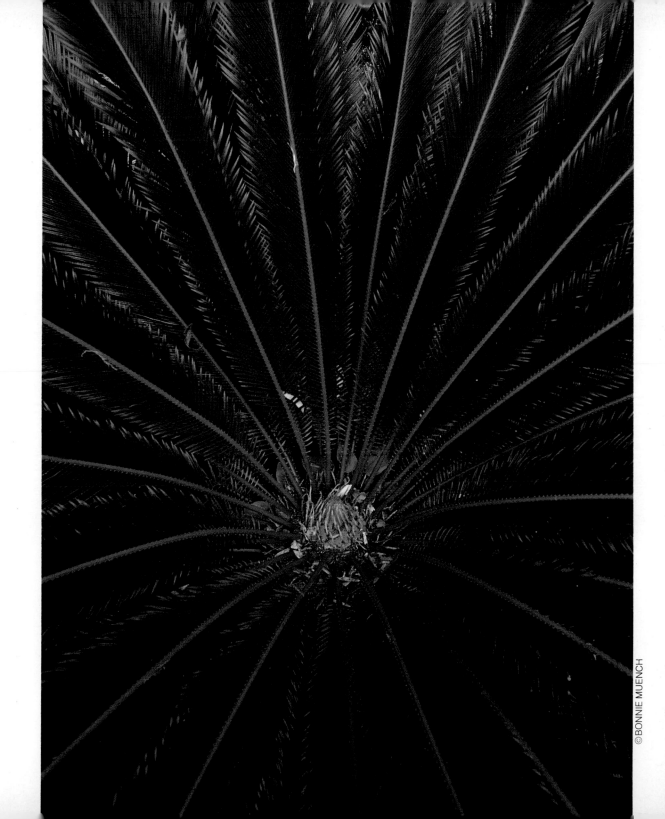

70 *(left)* Periwinkle in Akaka Forest
Preserve, Hamakua Coast, Hawaii

71 Interior design of cycad, Olu Pua
Botanical Gardens, Kauai

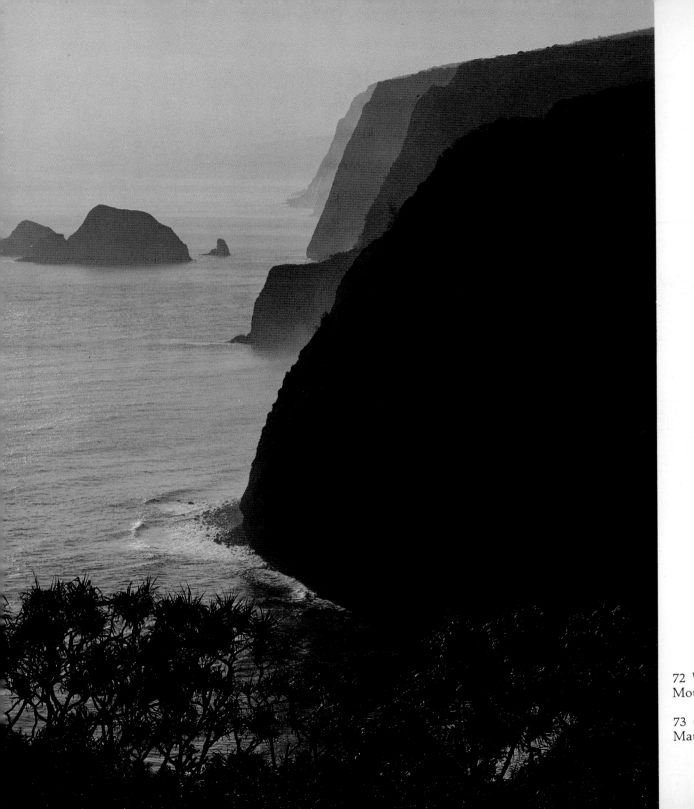

72 Weathered cliffs of the Kohala
Mountains at Pololu Valley, Hawaii

73 *(right)* Evening on the Haleakala road,
Maui

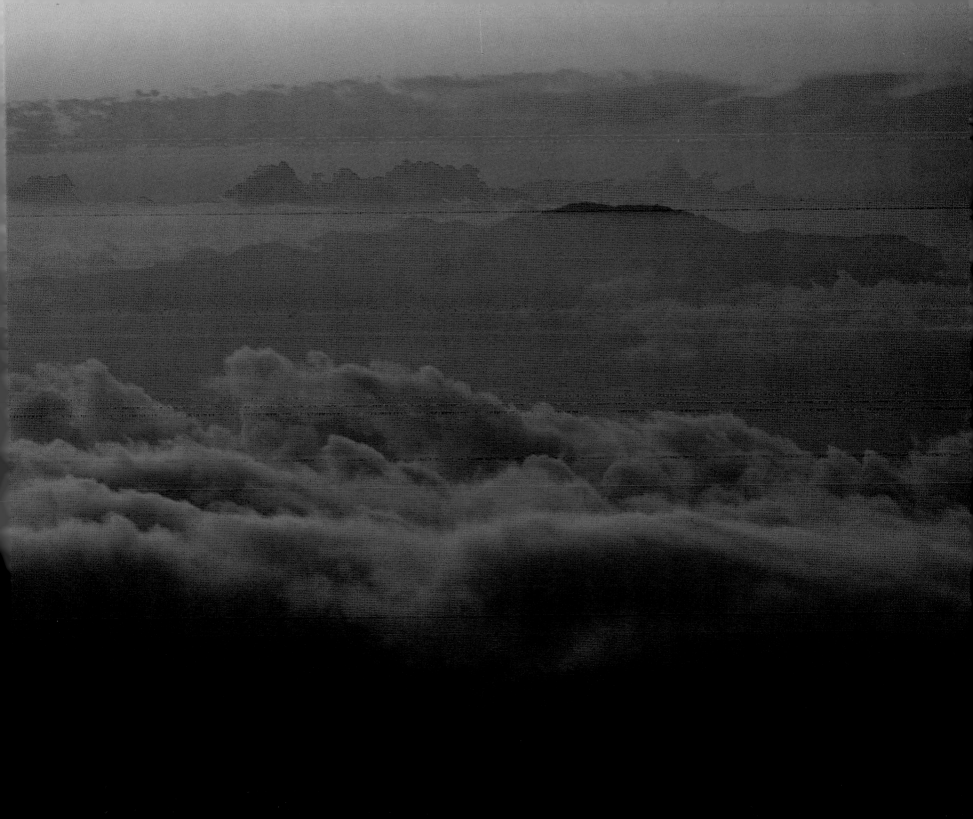

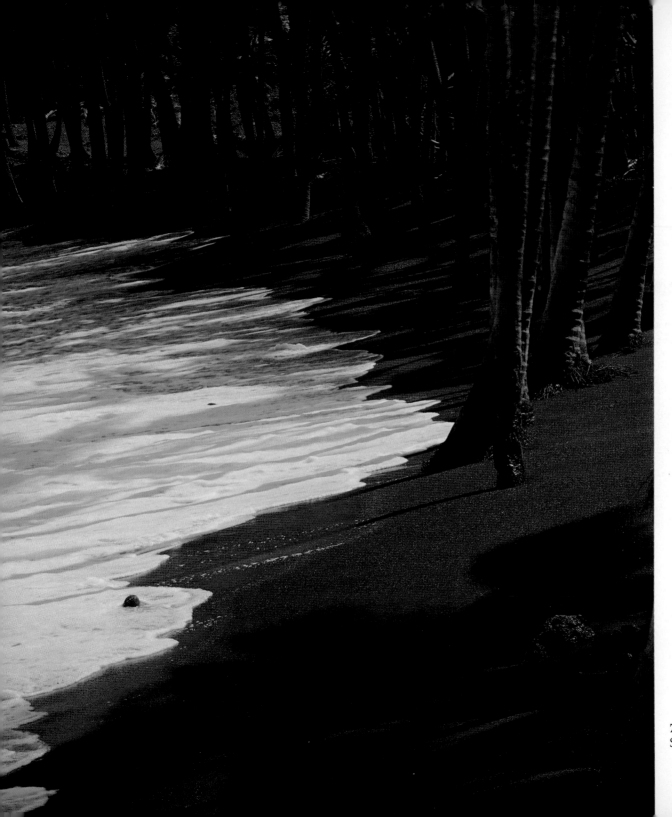

74 Coco palms and surf, Kalapana Black
Sands Beach

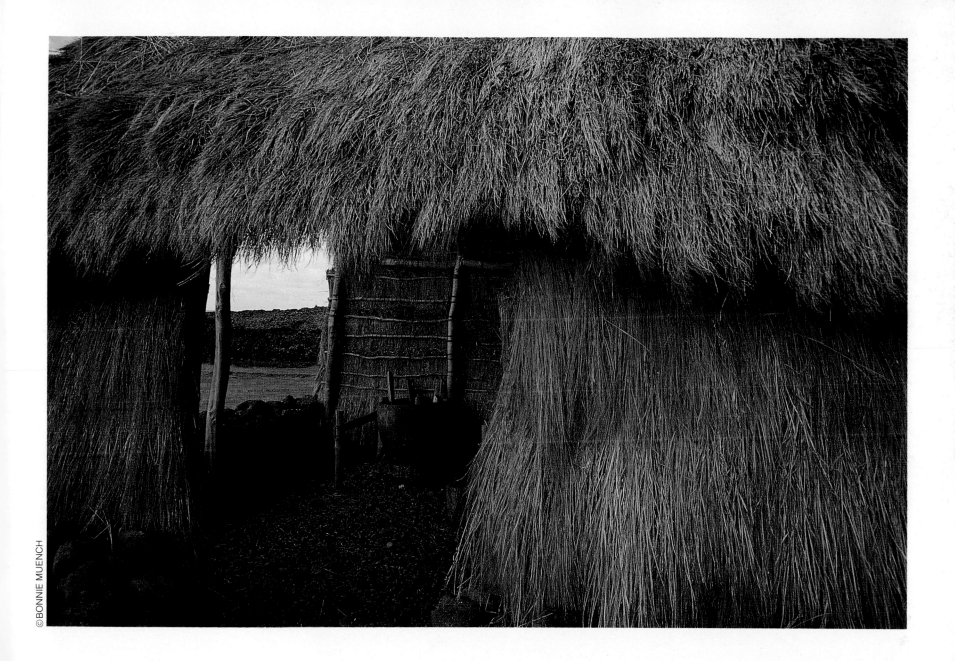

75 Thatched dwelling at Mookini Luakini *heiau* (temple), North Kohala, Hawaii

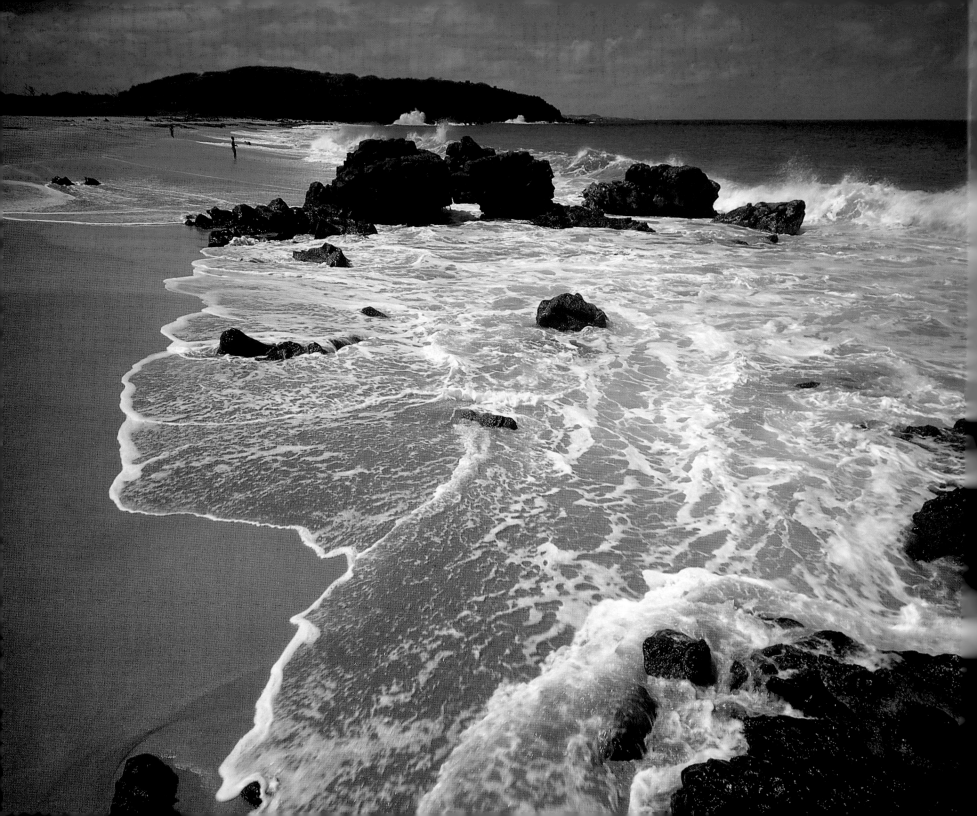

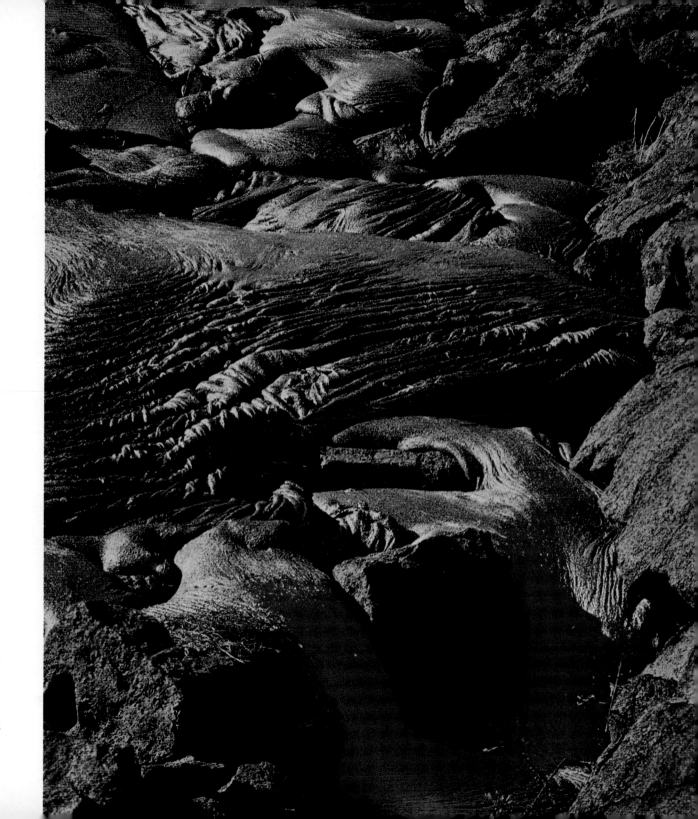

76 *(left)* Leeward surf and volcanics on
Kepuhi Bay, Molokai

77 Lava flowing toward the sea from
Halina Pali, Hawaii Volcanoes National
Park, Hawaii

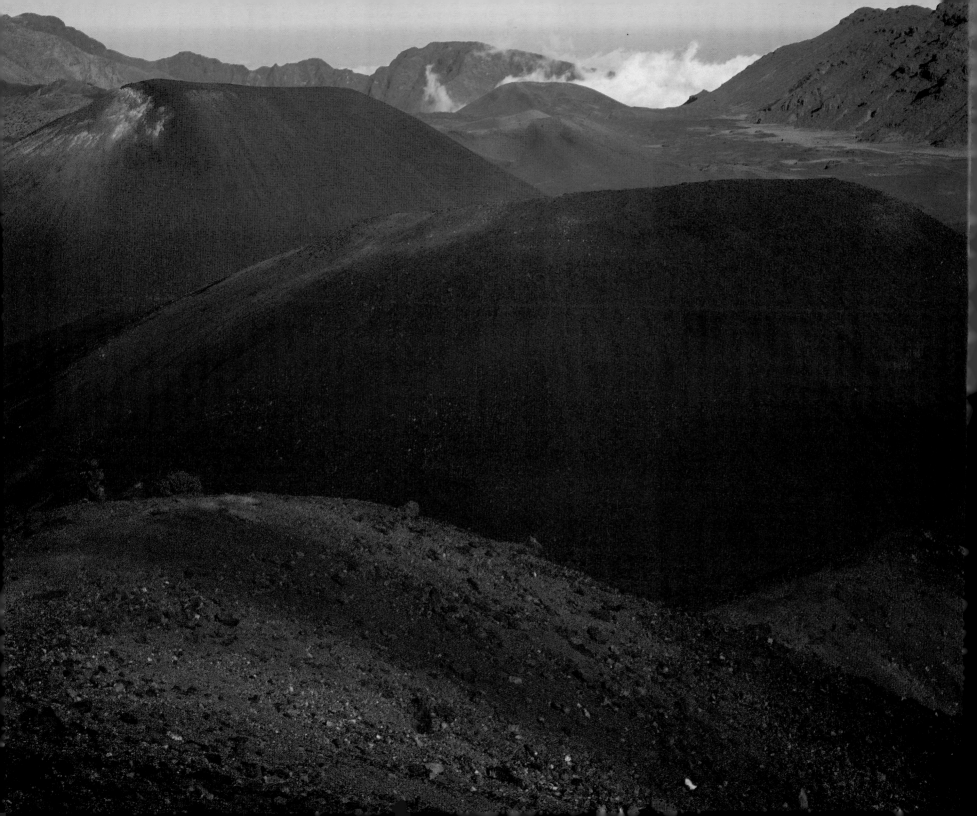

78 *(left)* Haleakala Crater interior with cinder cones and Kaupo Gap, East Maui

79 Hibiscus bloom, the 'Garden Isle' of Kauai

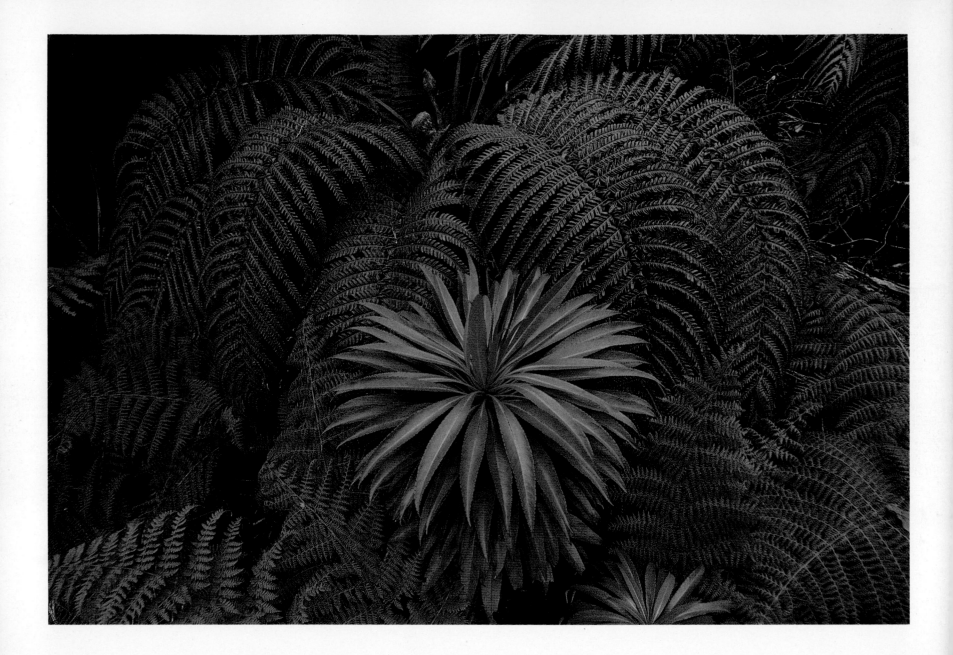

80 Iliau and amau fern, Wainiha Pali, Alakai Swamp, Kauai

81 *(right)* Volcanic remnants and pandanus in Pailoa Bay, Waianapanapa State Park, Hana, Maui

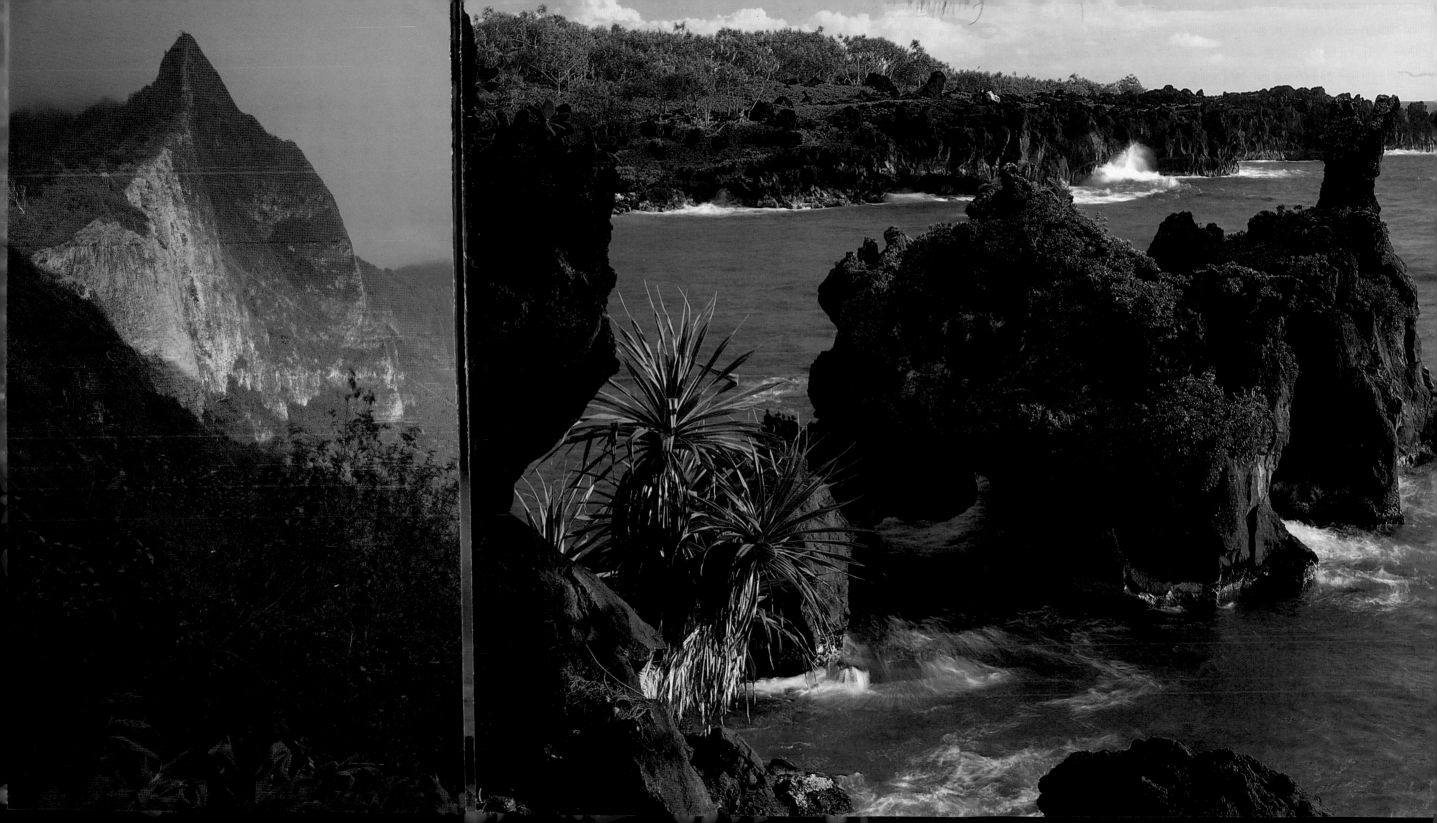

86 Protective wooden god images, Hale O Keawe *heiau* (temple). Puuhanua O Honaunau, South Kona, Hawaii

87 *(right)* Coco palms, South Kona Coast, Hawaii

88 *(overleaf)* Wainiha Bay coastline at Hanalei, Kauai

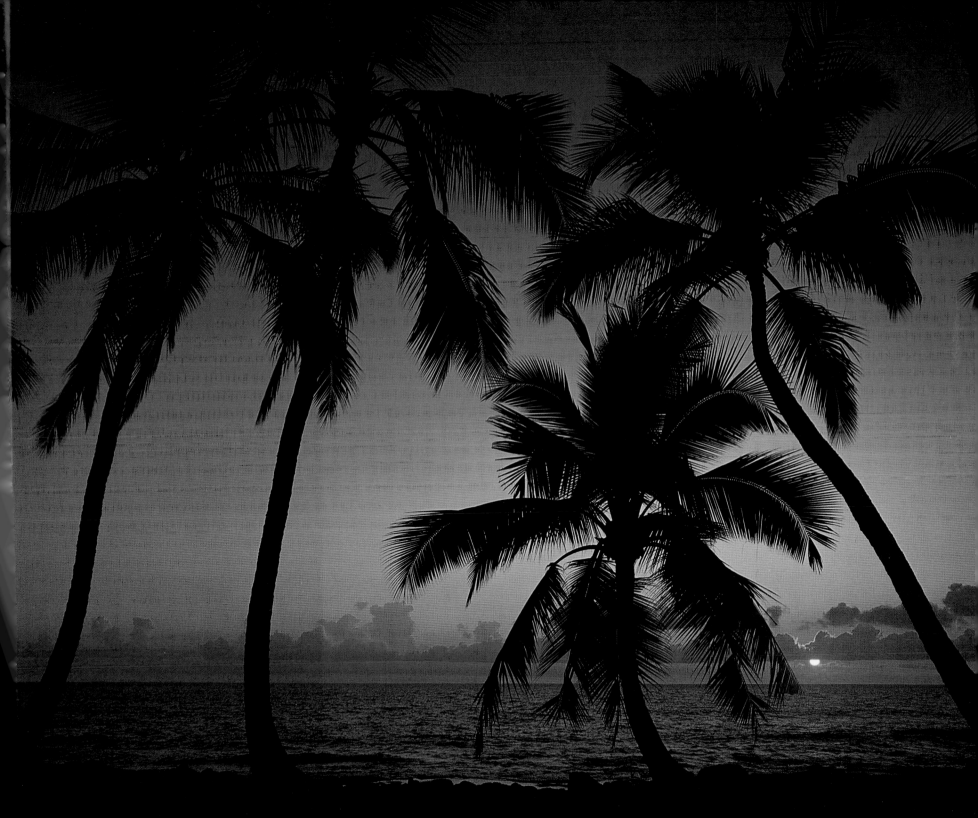